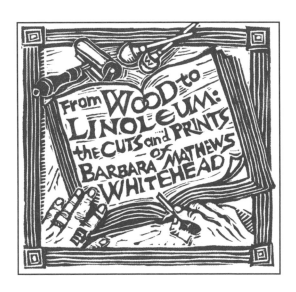

From WooD to LINOLEUM: the CUTS and PRINTS of BARBARA MATHEWS WHITEHEAD

From Wood *to* Linoleum

The Cuts *and* Prints *of*

TCU PRESS *Fort Worth*

BARBARA MATHEWS WHITEHEAD

Introduction by LONN TAYLOR

Library of Congress Cataloging-in-Publication Data

Whitehead, Barbara Mathews.
From wood to linoleum : the cuts and prints of Barbara Mathews Whitehead /
introduction by Lonn Taylor.—1st ed.
p. cm.
Includes bibliographical references.
ISBN-13: 978-0-87565-327-3—ISBN-10: 0-87565-327-8
(trade paper : alk. paper)
1. Whitehead, Barbara Mathews. I. Title.
NE1112.W47A4 2006
769.92--dc22
2005035528

Printed in Canada

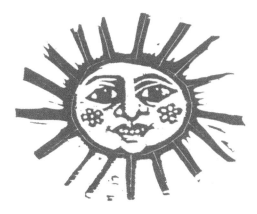

For Fred

and for

Bruce

with gratitude—

you have given your support and love

always

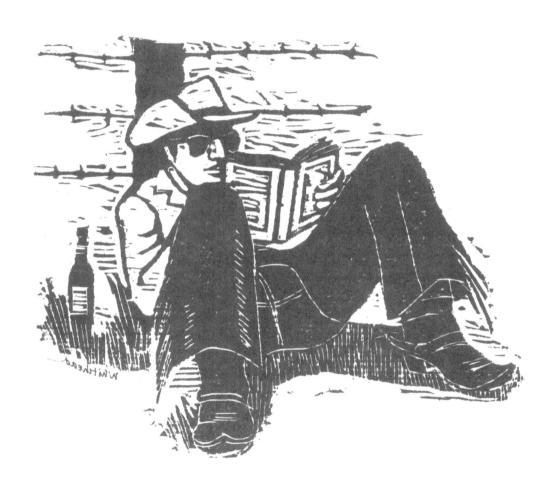

Texas Books in Review / cover 1983

Contents

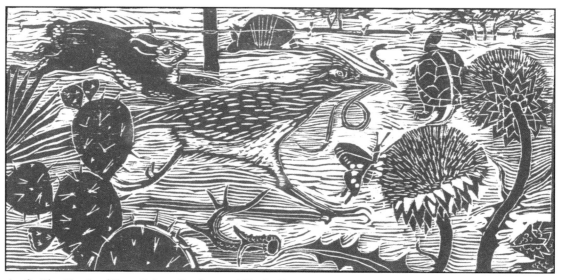

Art for The Mosaic of Texas Culture Conference / Hardin Simmons University

Foreword

BACKGROUND

WORLD WAR II and the invasion of Normandy changed the course of the world and also changed the course of my life. I was a toddler when, on D-Day, June 6, 1944, my father was killed during the invasion. I grew up as if I were an only child with the full attention of my mother. My three half-brothers were grown and only came home for vacations. Mother was a creative seamstress and embroiderer who encouraged me to work with my hands. We often took art classes together, went to museums, and moved around the country in search of a place Mother could call home. With my mother's guidance my early visual taste was formed. I spent hours drawing while lying on the floor, listening to the radio, and daydreaming. Daydreaming and solitude are still an important part of my creative life. I remember, while living in New England, the school desks had built-in inkwells and I couldn't wait for penmanship class to try out that ink with the scratchy steel penpoint. My early training has served me well and I am still working to perfect my technique with pens and colored pencils.

The Korean conflict brought about the next change in my family. My brother Steve, fresh from West Point, received a severe head injury in Korea that required intense rehabilitation. Mother wanted to provide him with a home base while receiving these treatments so we moved with him from hospital to hospital. After living in various New England states, Florida, and a brief stay in Tennessee, we finally settled in Austin, Texas. At the University of Texas I was lucky to have life drawing classes with Charles Umlauf who gave me the basis of everything I have done since. Connie Forsyth taught me printmaking techniques—lithography, etching, aquatint, wood engraving, and woodcut. I was excited by the whole process of making plates and being able to make multiple prints from one matrix. Professor Forsyth had us cleaning off old drawings on the litho stones by gliding one heavy stone over another with pumice sandwiched between, twisting and turning the top stone in a cleaning dance. This ninety-eight-pound professor would slap down the large leather roller onto the inking palette rolling it until it had the right "sticky sound" that indicated it was ready for use on the stone. After graduation I no longer had access to the school's equipment so my printmaking was limited to the simpler process of making woodcuts which required only a few sharp tools, a plank of white pine, ink, brayer, rice paper, and me. I still listen for that "sticky sound" as I use my brayer to prepare the ink for printing.

For college graduation my mother gave me, and herself, the "Grand Tour of Europe." For our first winter we lived in Rome and I studied at the Accademia di Belle Arti. In addition to drawing and painting, I took an etching class. After making our etching plate we were not allowed to print it ourselves in the European tradition. I missed the hands-on pleasure of discovery as the paper peels off the plate. After the school year we toured the continent and

England by car, stopping wherever and whenever we saw something of interest. Mother was a great and easygoing traveler.

We returned to the United States, and I chose to live in Woods Hole, Massachusetts, where my half-brother was living. I worked for the next year at the Woods Hole Oceanographic Institution. In their art department I did drafting and drawings of their research vessels for an atlas and made displays explaining various ocean sampling techniques. The offering of a new book arts course at my alma mater called me back to Austin. This course was being taught by an Englishman, Kim Taylor. With the influence of my new mentor I studied the history of the book, and was introduced to the world of calligraphy. He greatly admired woodcuts and used the work of woodcut artists to illustrate books that he designed. I tried out my woodcutting skills in his book arts class. During that time, Taylor was also working as a book designer for the University of Texas Press. He had used a woodcut illustration by Antonio Frasconi for a bookjacket for *Dreamtigers* by Jorge Luis Borges. My success in his class was a pivotal point in my education—I had found a passion that I have been happily practicing ever since. While I finished my thesis for my Masters degree, Taylor gave me the opportunity to illustrate a small book of poetry by D.H. Lawrence titled *The Body of God* (Ark Press, England). It didn't matter a bit that there was no budget for illustrations; it was my big chance to be published. Many years later I received an unexpected check in the mail from Kim Taylor for those illustrations.

While in graduate school I married my undergraduate art school sweetheart, Fred Whitehead, and together we started out on our crooked road toward the world of book arts. Our first office was at home where we worked on the design and production of books and other graphic design work. We

raised our only child, Elizabeth, with both of us working at home. We had the good fortune to be able to work at what we loved, be with our child, and have enough for the simple pleasures. Later we had an office in downtown Austin, then moved to the small town of Smithville, Texas. We worked together for over twenty years designing and producing books for various presses until Fred's premature death. I have continued our business ever since on a smaller scale.

WORK

WOODCUTS or wood blocks have the image in relief—all the areas that are to be white must be cut away. The raised areas that are left are inked with a brayer, the paper is then placed onto the inked block, and pressure is applied to the back side of the paper. When the paper is lifted, the ink has been transferred from the block to the paper. The block is then re-inked for the next print.

The properties of wood and linoleum are quite different. I use clear white pine with as few knots as possible. The grain of the wood certainly affects the cutting—tools cut easier parallel with the grain and up to about a forty degree angle off the parallel. Otherwise, after that the wood starts to splinter. When it is necessary to cut at right angle to the grain, I score a line first with a knife, then make my cut, trying to avoid splinters. Since wood is harder than linoleum it requires strength—especially because I hold the wood in place

firmly with the left hand while cutting with my right. I am careful not to cut myself by always having my left hand used as a lever under my right one. Linoleum cuts like a dream in any direction allowing a freer design. Depending on the design, I use either medium interchangeably.

The prints made from linocuts and woodcuts can be distinguished from each other by the discerning eye. The grain or imperfections of the wood are often seen in the print and are considered desirable. Linocut prints, on the other hand, print more evenly although the surface can be roughed up to give it a grainy appearance.

Because alterations to the blocks are difficult or impossible, I carefully plan the initial drawing. Both my clients and I want to know how the end result will look. I work over the drawings thoroughly—I always have a good eraser and a wastebasket for bad starts. I do a lot of research on my subjects in order to get them right. Besides using the public library, I have a file of various subjects clipped from magazines, and my own library containing books that cover a huge variety of subjects. At flea markets I find photos or objects that I use for ideas and I keep a sketchbook of natural life—shells, dead birds, flowers, and small dead animals. I also have a collection of taxidermy and skulls, much to the disgust of my family. And, as Barry Moser, the wood engraver wrote in his book *In the Face of Presumptions,* "Illustration is a thief's profession because we steal. We steal from the dead, we steal from the living, and we steal from ourselves."

Once the drawing is made, I transfer it onto the wood by placing the drawing face down on a freshly sanded plank. Having taped it in place, I trace it with a hard pencil. I remove the original drawing and spray the block with fixative to prevent smudging. The drawing that has been transferred will be backward

and will be cut that way. When it is printed it will read correctly again. If the final print is to be in color, each color is normally cut on a new block.

I use only four or five tools to make the cuts—various sizes of "U" shaped gouges, one "V" shaped, and a knife for straight cuts. When I feel close to finishing I make a proof print to check my image knowing that what has been cut away can't be put back. Once the corrections have been made, I am ready to print. I use acid free rice paper or hand-made paper untreated with sizing or glue. I generally use water-based inks made for woodcut or linocut prints. To make the print I use a one-inch flat roller designed for applying wallpaper that I found many years ago in a paint store. The slight variations in a hand-pulled print are inevitable and show the individuality of each print. I much prefer the softer effects of the manual print to the solid black images made by a press.

Barbara Mathews Whitehead
Austin, 2006

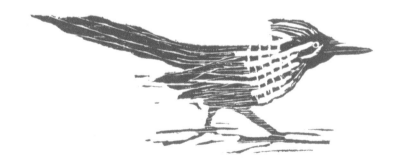

Introduction

For the past thirty years I have worked under portraits of three of my heroes on the wall above my desk. They are woodcut portraits of Sam Houston, J. Frank Dobie, and Charles Goodnight, done by my friend Barbara Whitehead for Bill Wittliff's Encino Press in the early 1970s.

I first met Barbara and her husband, Fred, when I lived in Austin in the mid-1960s. They were only recently married and were struggling to make a living as artists, doing graphic design for advertising firms to bring in cash and showing their work at places like Laguna Gloria's annual fiesta and Dave and Mary Jane Hickey's gallery, A Clean Well-Lighted Place. Over the years, my three portraits have been a constant reminder of Barbara's skill and genius, as well as of our long friendship.

For me, Barbara Whitehead's work has always had a boldness and assertiveness about it that I find peculiarly Texan even when her subject matter is not about Texas. She grew up in Austin and did her undergraduate work at the

University of Texas before spending a year at the Accademia di Belle Arti in Rome, and then returned to Austin in 1964 to enter graduate school, where she studied under Kim Taylor in UT's book arts program. The mid-60s were particularly fertile years in Austin for writers and artists and the Whiteheads were part of a loosely-knit circle of overlapping friendships that centered on A Clean Well Lighted Place and included Dave and Mary Jane Hickey, Fred's brother Glenn Whitehead, Jim Franklin, Barry Buxkamper, Terry Allen, Luis Jiminez, Bill Helmer, Roxy and Judy Gordon, Gilbert Shelton, Dave Oliphant, and Jack Jackson. We were not a movement or even a group—most of us were too anarchistic and too determined to follow our own vision for that—but we were drawn together by a common feeling of alienation from mass culture and by what we regarded as our heightened sense of the absurd. One of the Whiteheads' early joint exhibits at St. Edward's University in Austin was called "The Air Show." It featured a biplane-like sculpture by Fred, all struts and wires and fabric-covered wings, and woodcuts of airplanes by Barbara. They appeared at the opening wearing World War I leather pilots' helmets and silk scarves. For a while before his marriage to Barbara in 1966 Fred Whitehead and his brothers Glenn and Kinney shared an enormous old Victorian house near the state capitol with Bill Helmer and several other friends who came and went, and much of our group's social life revolved around that house and a nearby beer garden, the Scholzgarten. Helmer was writing an American studies dissertation on the Thompson sub-machine gun (later published under the title *The Gun That Made the Twenties Roar*) and he was the founder of the John Dillinger Died For You Society, whose membership cards, which he printed up on a press on the second floor of the house,

had a round hole in the center and the legend "Place This Card Over the Muzzle of a Tommy Gun and It Will Get You Anything You Want." Helmer had acquired the press and an enormous case of metal type from an Austin printing shop that went out of business, and he later sold them both to Barbara Whitehead.

In 1970 I moved away from Austin to become the curator of the University of Texas Winedale Inn Properties (now called the Winedale Historical Center), a restored nineteenth-century farmstead near Round Top, in Fayette County. The eight historic buildings there had been presented to the university by Miss Ima Hogg of Houston for use as a museum of early Texas decorative arts and a study center. I wanted to establish a unified graphics program for Winedale, and I turned to the Whiteheads, who by then had established a graphics design firm in Austin. For the next few years they designed the posters and brochures for Winedale's public programs, our newsletter, and our stationery, which they based on nineteenth-century letterheads in the University of Texas archives. In 1974 they designed my very first publication, a little pamphlet entitled *Texas Germans: A Bibliography,* which we sold to our visitors for twenty-five cents. Two years later they designed a booklet called *Christmas in Troubled Times,* which we sent to members of the Friends of Winedale as a Christmas gift. It was a reminiscence of a Texas Civil War Christmas, written in the 1890 by William Trenckmann, publisher of *Das Bellville Wochenblatt* and translated from Trenckman's original German by my friend Anders Saustrup. Barbara did a wonderful woodcut of a dog-run cabin buffeted by the winds of winter and war to illustrate it, a small gem that is among my favorite examples of her work.

The first year that I was at Winedale Barbara also designed my wife's and my Christmas card, a woodcut that showed us as angels hovering over the museum's main building (looking back, I am somewhat embarrassed by the egoism of it) and holding a scroll with a Christmas message on it. I told Barbara that I wanted to print our own cards, and so she gave me the woodblock she had carved, and I took it over to Bill Holman's house to print the cards on his hand press. After I had been printing for a half hour or so my back began to hurt, and I straightened up from the press to stretch. "Does your back hurt right here?" Bill asked, putting his hand on his lower back. When I said that it did indeed, he said, "That means you've done about twenty-five cards. When you've done seventy-five, it'll hurt all up and down your spine." As I turned the crank on the press I mentally revised our Christmas card list for that year.

In 1969 Barbara started doing woodcut illustrations for Bill Wittliff's Encino Press, established in Austin in 1964. Over the next eight years she illustrated nineteen books for Encino Press, and it was in this way that her work first became widely known among collectors and lovers of fine printing. She has told me that her favorite Encino Press book is *Growing Up in Texas,* a collection of reminiscences by thirteen Texas authors, including Bertha Dobie, Terrell Webb, Joe Frantz, John Graves, and A.C. Greene, published in 1972. This was a productive period for her. 1972 also saw the publication of *This Bitterly Beautiful Land: A Texas Commonplace Book,* which many consider the most beautiful book ever published in Texas. It was designed and printed on hand-made paper in Austin by Bill Holman, and consists of forty quotations about Texas selected by Al Lowman and thirty-six of Whitehead's

woodcuts. Two years later she illustrated David L. Lindsey's *The Wonderful Chirrionera and Other Tales from Mexican Folklore* for Lindsey's Heidelberg Publishers in Austin. Each of the tales is illustrated with a full page woodcut in black and red, and the initial letter of the text on the facing page is a woodcut that refers to the illustration opposite it. *The Wonderful Chirrionera* marks Barbara's transition from illustrator to designer and illustrator, which undoubtedly accounts for the pleasing placement of the woodcuts within the text. She has told me that, although she had studied book design with Kim Taylor, she really did not become involved with its practical problems until she started working with Bill Wittliff and decided that she wanted to try her own hand at it. In 1981 she and Fred, as Whitehead & Whitehead, started designing books for the University of Oklahoma Press, eventually adding Texas Tech Press, Southern Methodist University Press, the University of New Mexico Press, the Book Club of Texas, Shearer Publishing, and Texas Christian University Press to their list of clients. She continued to do book design work after Fred's death from cancer in 1992.

Barbara's woodcuts for *The Wonderful Chirrionera*, with their incorporation of Mexican folk themes such as dancing goats, disembodied heads, terrified peasants and calaveras (lifelike skeletons), reveal the influence of the Mexican woodcut artist Jose Guadalupe Posada (1852-1913) on her work. Even in her woodcuts with non-Mexican subjects, Posada's earthy humor, his blocks of solid color, and his sense of motion show through in Barbara's work. Early on the magazine *Texas Monthly* commissioned a cover from her and she gave them a woodcut based on one of Posada's. It became the cover of the worst-selling issue in the magazine's history, she says, and since then most of

their covers have featured pretty women or strong-jawed men. However, Posada's influence continues to find its way into her book illustrations, which do not need to attract news-stand browsers. Another important influence, she has told me, were the forceful, gaily colored woodcuts of the Uruguayan artist Antonio Frasconi, (born 1919), whose work she first saw in the late 1950s and early 1960s.

The process by which Barbara Whitehead creates images is largely one of absorption and cogitation, a process with which I, as a historian, can empathize. She loves doing research in a wide variety of historic visual sources. When she was working on the illustrations for R.G. Vliet's long poem *Clem Maverick: The Life and Death of a Country Singer* (Bryan: Shearer Publishing, 1983), a book which has become a Texas classic, she based her woodcuts on old Hank Williams record album covers. She has also used old prints and engravings, photographs, advertising copy—anything with images on it. "Then," she says, "I go off in another world somewhere and concentrate on the subject I'm working on, and while I'm driving off to the grocery store or somewhere it comes to me." She has an astonishing memory for visual details. Not long ago she was describing Kim Taylor, whom she has not seen since 1968. She mentioned his snow-white hair and ruddy complexion, and then she said, "and he always wore those wide-wale buff-colored corduroy pants," and suddenly I could see him perfectly, striding along Guadalupe Street in his corduroy pants.

Many of Barbara's woodcuts include words. In my portrait of Charles Goodnight, his head and shoulders are surrounded by the rather intimidating phrase, "I'll be damned if I could ever find time to lie in the shade," and the

portraits of Houston and Dobie include similar characteristic quotations. Another of my favorite Whitehead woodcuts, derived from a book jacket she designed for an edition of D.H. Lawrence poems, depicts three nude figures surrounded by fruits and flowers and the words, "There is no God apart from the poppies and the flying fish and the women brushing their hair in the sun." Barbara says that her penchant for combining words and images started in her undergraduate years, when she was a painter and that she has always liked lettering and calligraphy (she is an expert calligrapher). During her year in Rome she studied ancient lettering in the inscriptions on the ruins that dot that city. On reflection, she thinks that she may have been influenced in the 1960s by the serigraphs of Sister Mary Corita (1918-1986), whose bright combinations of images and words extolling peace were extremely popular within the anti-war movement.

There are two books in my collection that, taken together, demonstrate the wide range of Barbara Whitehead's talents. Norman D. Brown's *Journey to Pleasant Hill: The Civil War Letters of Captain Elijah Perry, Walker's Texas Division, C.S.A.* (San Antonio: University of Texas Institute of Texan Cultures, 1982), was designed by Barbara and Fred. It is a big book. It runs to 471 pages, and it measures 8 1/2" x 11." The margins are very wide, just a tad over 2 1/2", and the type is set with a ragged right margin to preserve the feel of Captain Perry's handwritten letters. The design challenge that this book presented to the Whiteheads was to integrate 130 watercolors and drawings by John Groth into the text so that they appeared next to the incidents they illustrate. They solved this beautifully. Some appear in the margins; some occupy the bottom or top or even the middle thirds of pages; a few are full page or double-page

illustrations. In the process they became great friends with Groth and he and Fred became fly-fishing companions. Twenty years later, Barbara still remembers the pleasure that job gave both of them. The Whiteheads won the Institute of Texas Letters design award for *Journey to Pleasant Hill* in 1982. The other book, Carolyn Osborn's *The Grands* (Austin: The Book Club of Texas, 1990), is a small book—fifty-two pages, but every page is beautifully laid out, and they display twenty-five of Barbara's woodcuts. *The Grands* is the result of a very close collaboration between author and illustrator. Carolyn Osborn had her writing studio in the same Austin building as the Whiteheads' design studio, and they had designed one of her earlier books, *The Fields of Memory,* in 1984. Barbara's woodcuts of mules, coal-oil lamps, fiddles, and flappers dancing on a cabin porch render perfectly the 1920s Tennessee setting of Osborn's story. My favorite is a full page woodcut of a hand holding a paper fan with a depiction of Jesus on it, above a legend which reads "Your Friend in Hour of Need," a legend which you learn from the text refers not to Jesus but to the funeral home which provided the fan.

Barbara and Fred Whitehead's design work was so closely collaborative that she has told me that when Fred died she thought that she could never have an idea by herself. But she was working on a jacket design for a book of stories by Janet Peery called *Alligator Dance*, and she took a set of colored pencils and drew a wonderful dancing alligator, which became the book jacket. It was the first thing she did after Fred's death and she keeps it pinned to wall of her Austin studio. Since then she has done jacket illustrations in colored pencil as well as with woodcuts, most notably for C.W. Smith's *Understanding Women* (1998) and Mary Powell's novel about a Texas-German family, *Auslander* (2000).

But woodcuts remain Barbara's first love, and they are the medium she is most closely identified with. Her work is instantly recognizable; there is a unique quality about her vibrating lines and blocks of color that literally cause them to jump off the page. They are powerful because of the economy of line and mass that form them; at the same time there is a strong sense of the absurd in many of them. Barbara has always looked on life with an unflinching eye. Not long ago, discussing her work with me, she said, "Woodcuts get the essence, and I like to get at the essence of things." As you turn the pages of this book, you will see that she has always done that.

Lonn Taylor
Fort Davis, Texas

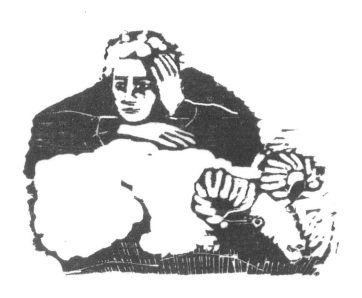

Illustration of Kim Taylor for privately printed tribute.

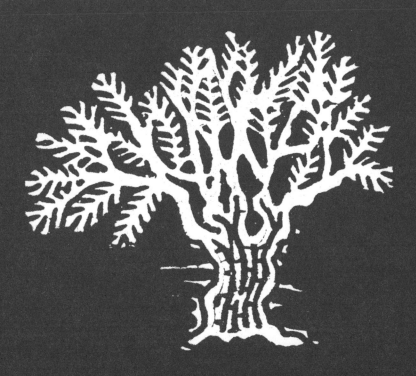

1 : Illustrated Books

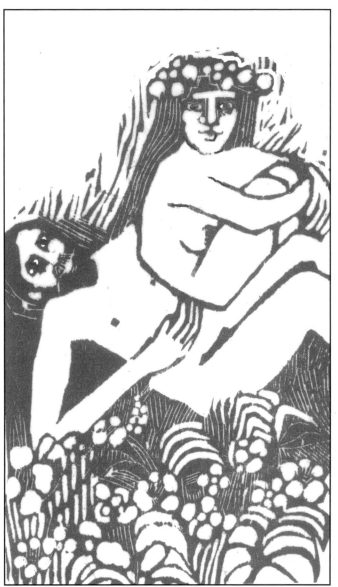

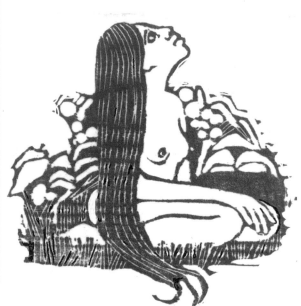

The Body Of God / Ark Press

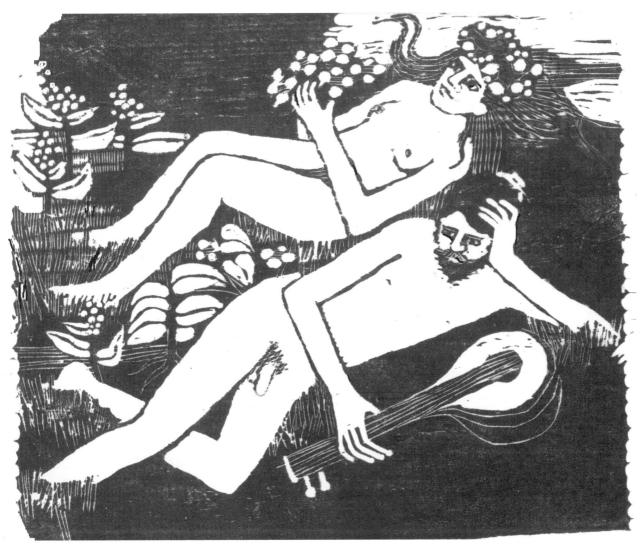

The Body Of God / Ark Press

13

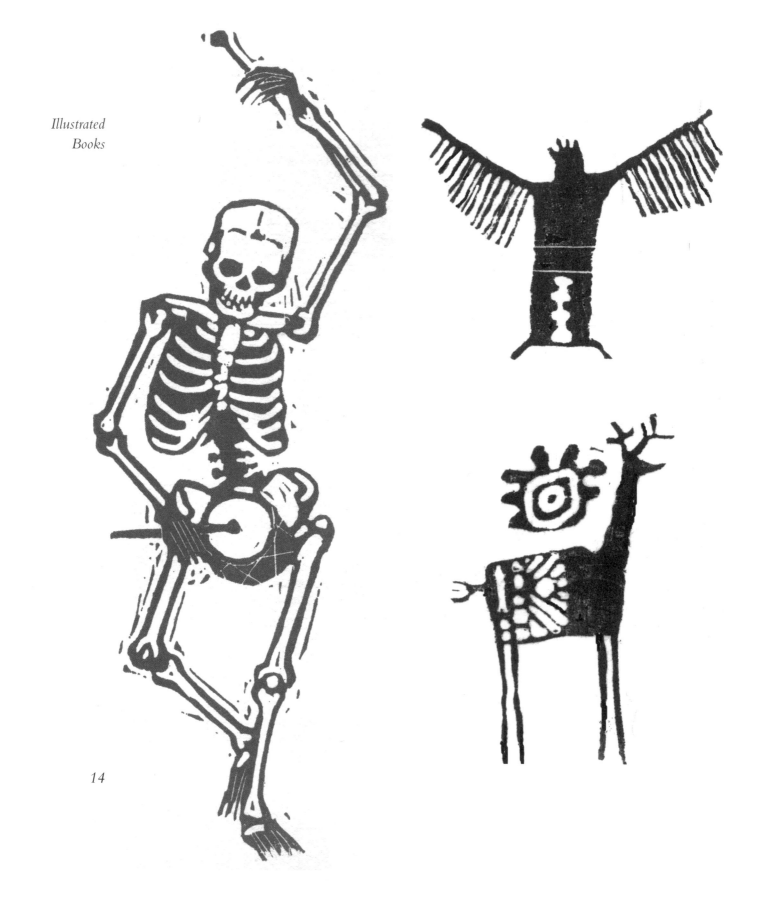

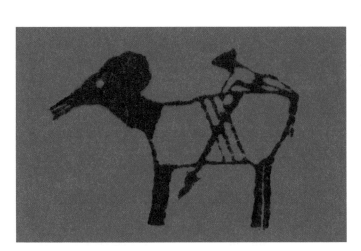

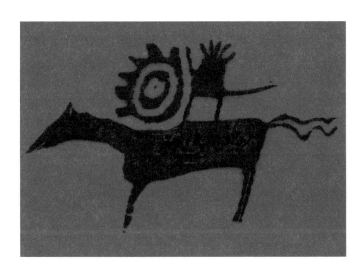

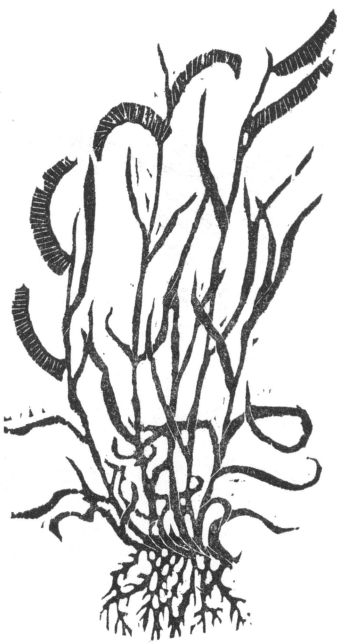

Opposite and this page:
This Bitterly Beautiful Land / Roger Beacham

15

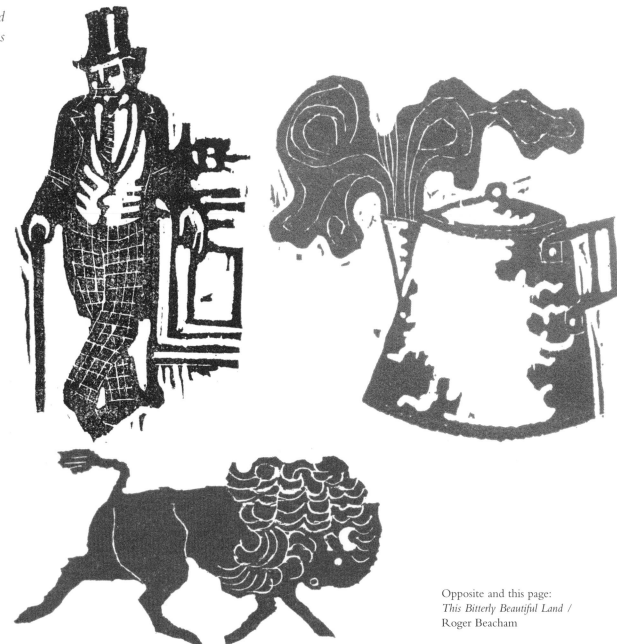

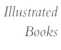

Opposite and this page:
This Bitterly Beautiful Land /
Roger Beacham

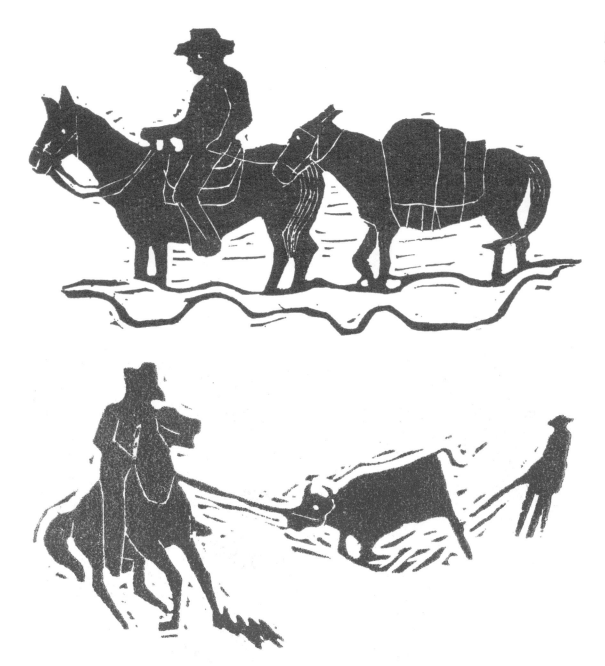

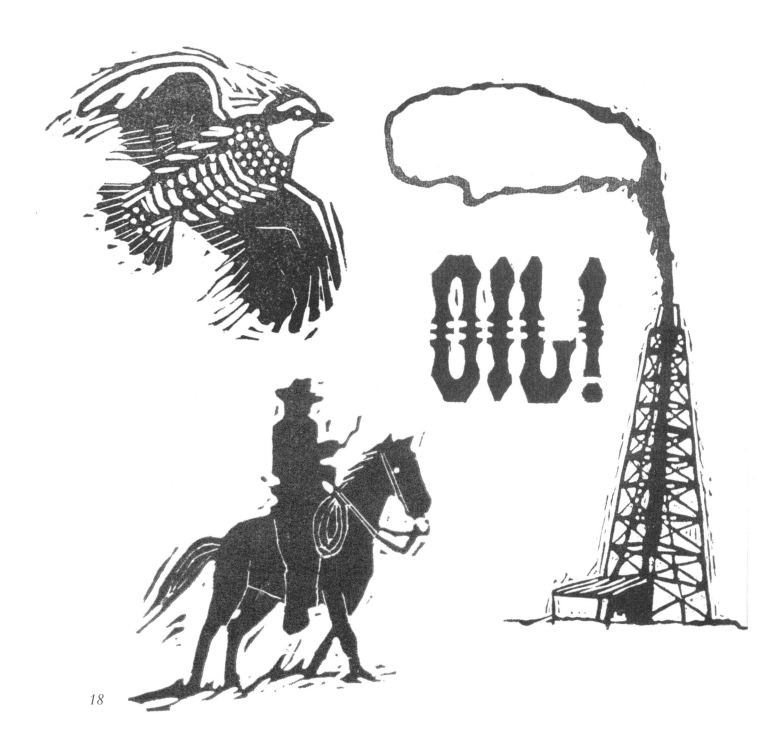

18

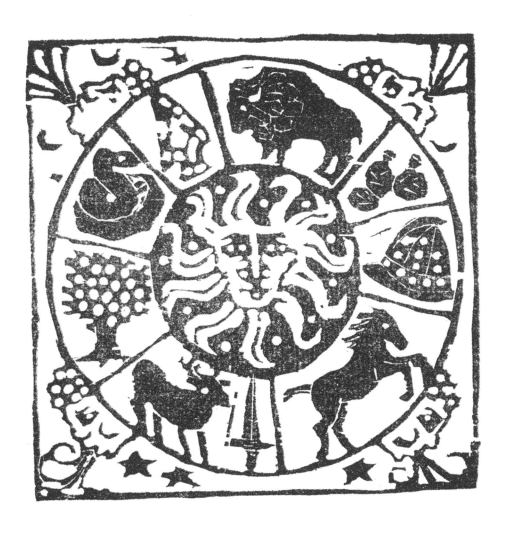

Opposite and this page:
This Bitterly Beautiful Land /
Roger Beacham

19

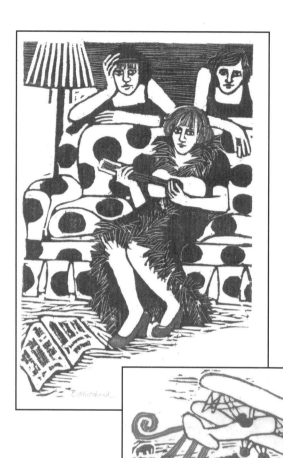

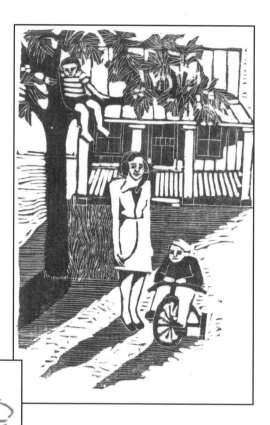

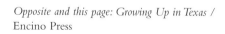

Opposite and this page: Growing Up in Texas /
Encino Press

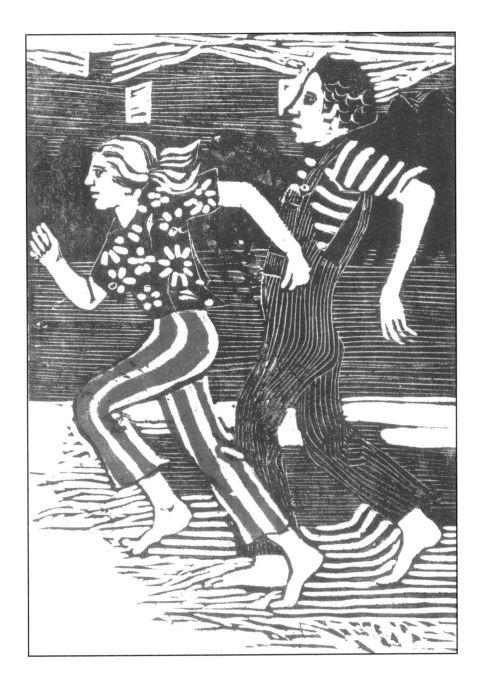

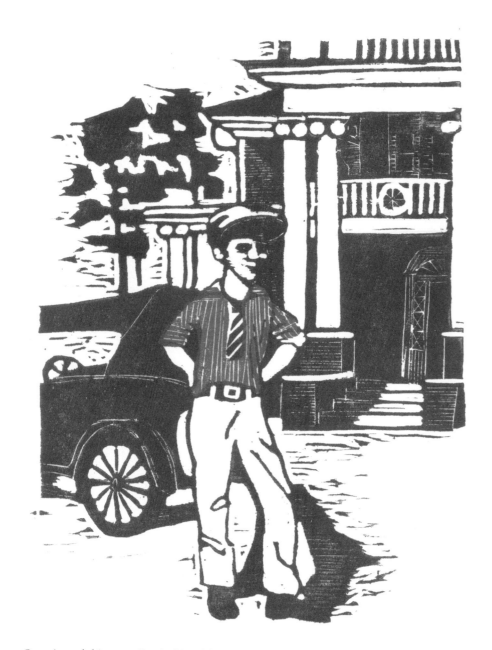

Opposite and this page: *Growing Up in Texas* / Encino Press

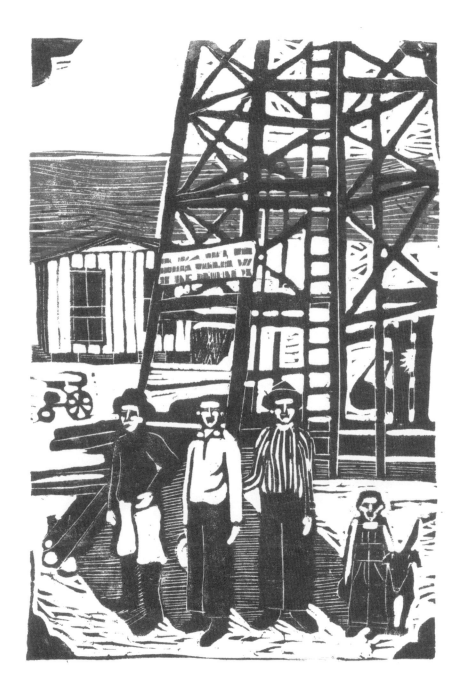

Opposite and this page:
The Texas Wild Game Cookbook / Encino Press

24

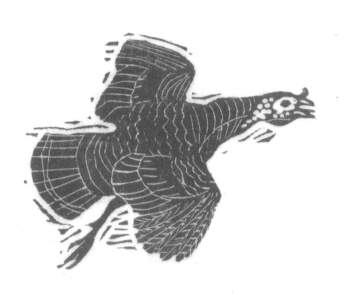

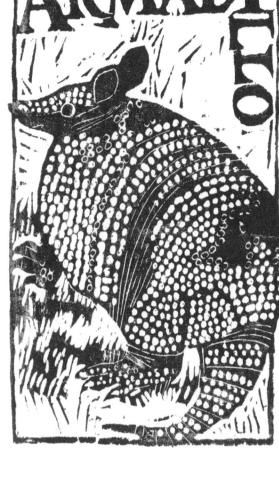

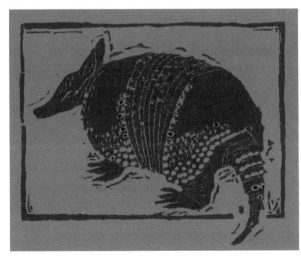

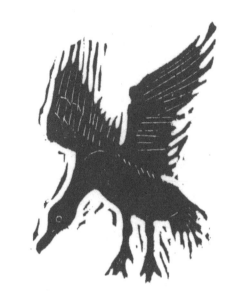

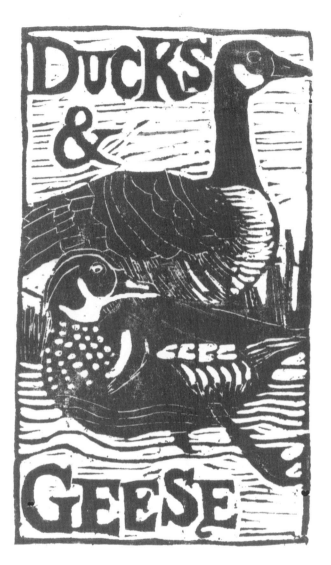

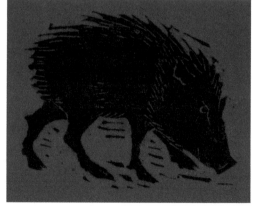

Opposite and this page:
The Texas Wild Game Cookbook / Encino Press

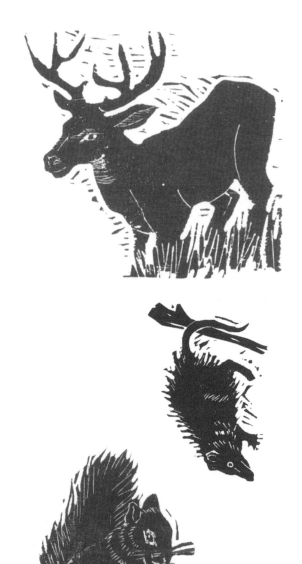

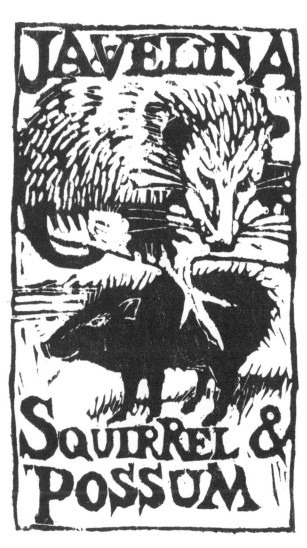

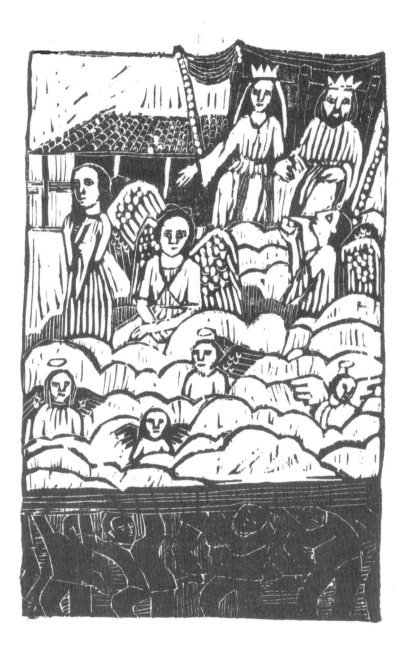

This page and opposite: *The Fair* / University of Texas Press

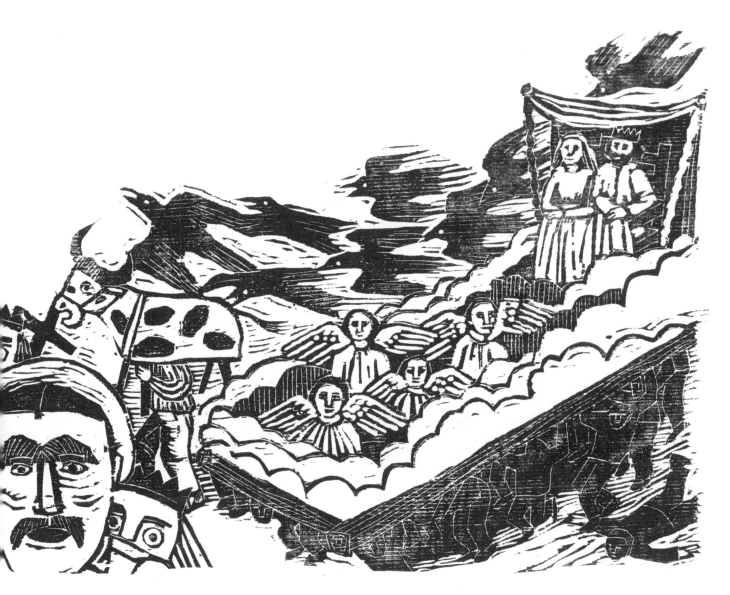

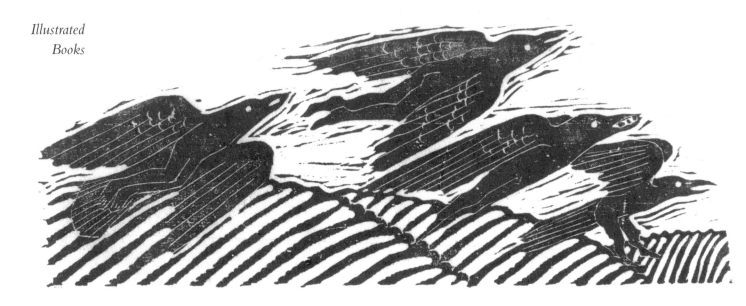

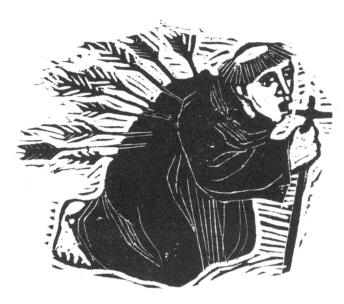

This page and opposite:
The Fair / University of Texas Press

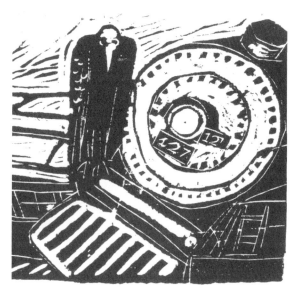

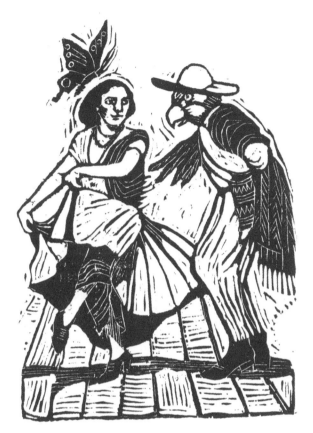

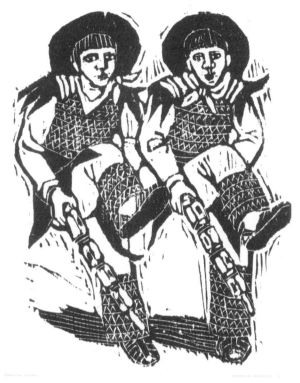

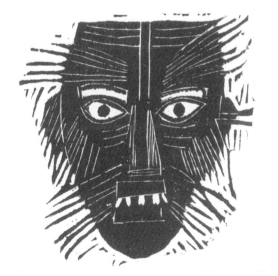

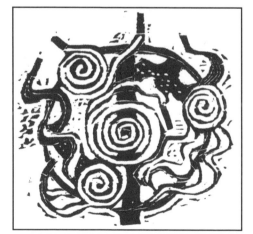

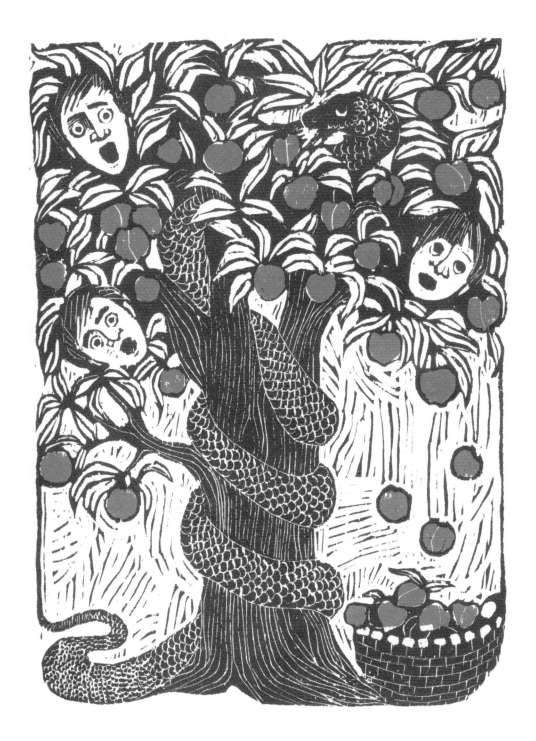

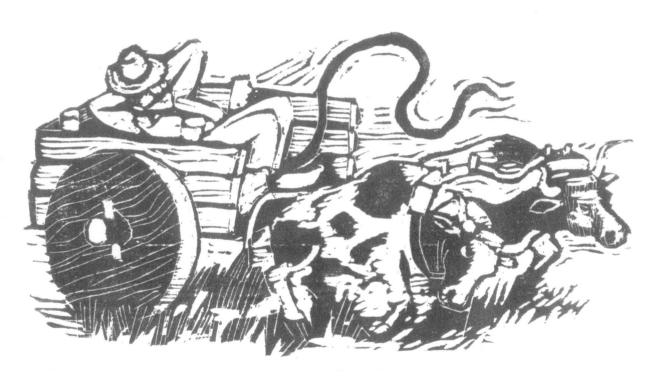

This page and opposite page: *The Wonderful Chirrionera* / Heidelberg Publishers

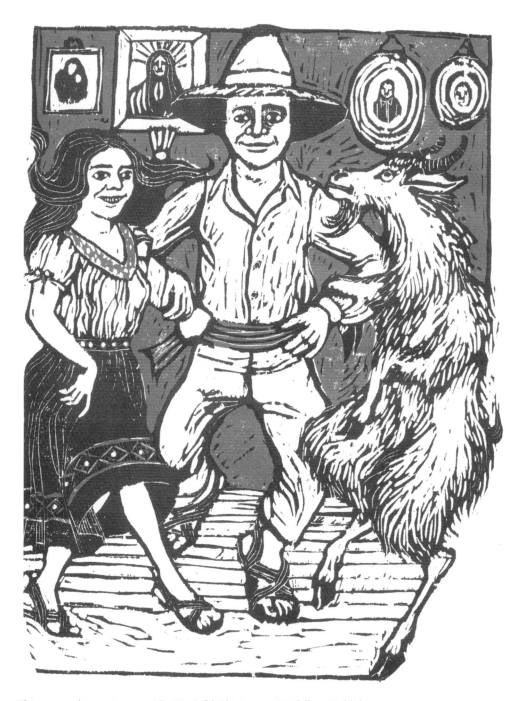

This page and opposite page: *The Wonderful Chirrionera* / Heidelberg Publishers

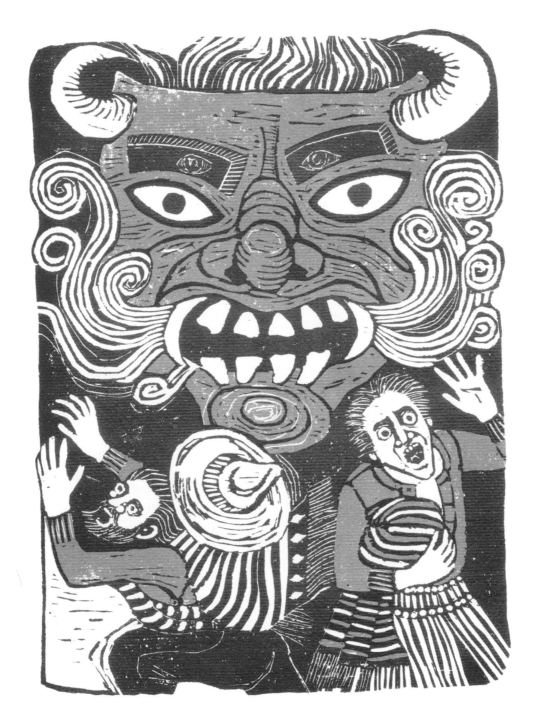

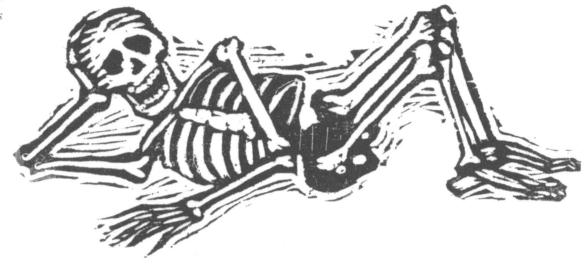

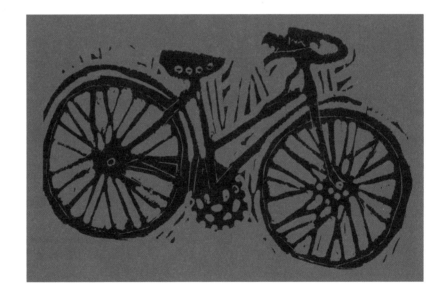

This page and opposite page: *The Wonderful Chirrionera* / Heidelberg Publishers

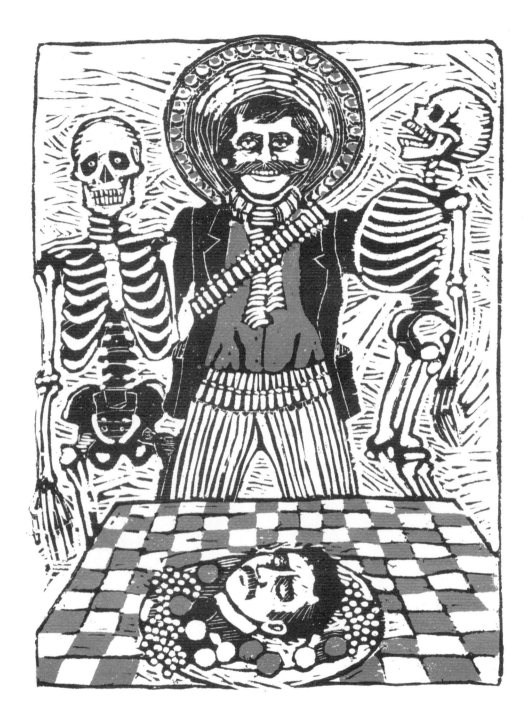

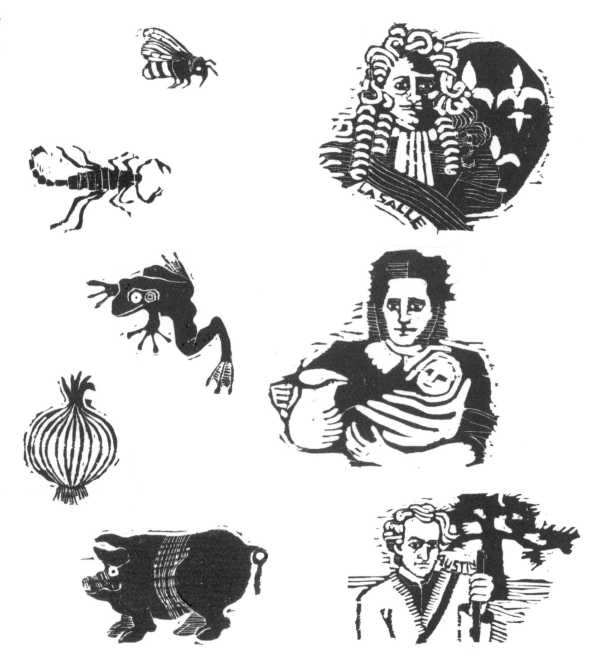

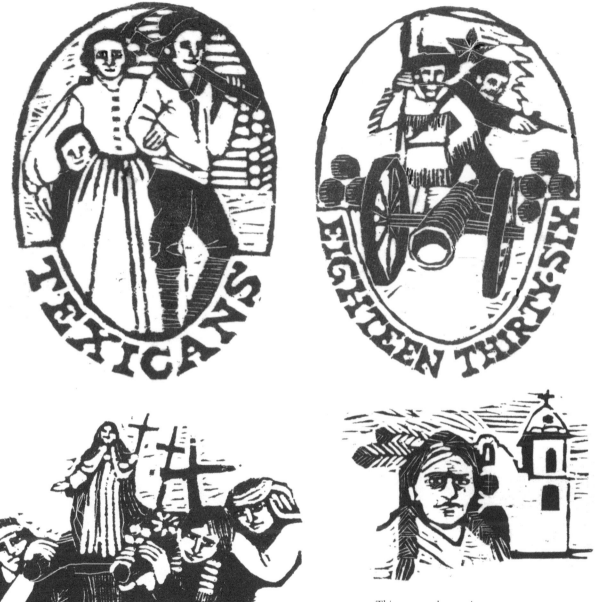

This page and opposite page:
Many Texans / Hendrick-Long / Encino Press

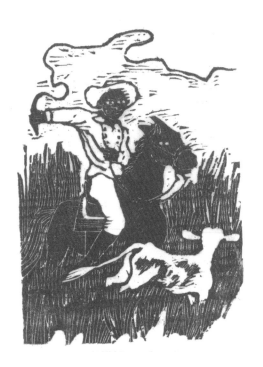

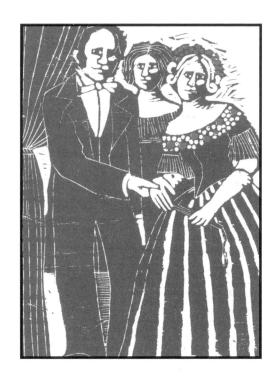

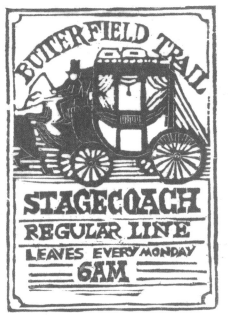

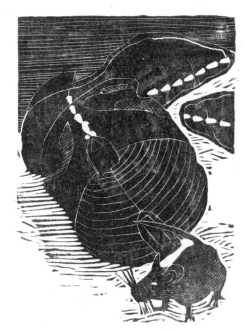

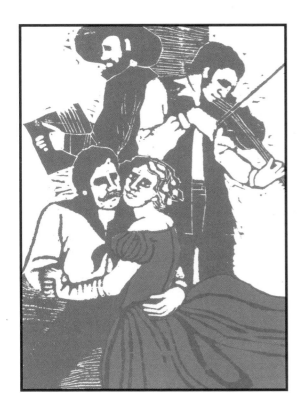

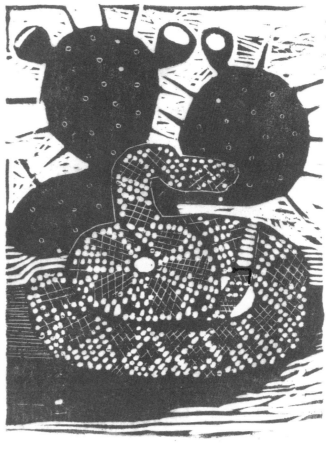

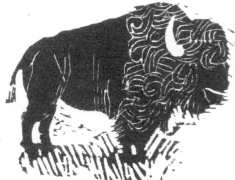

This page and opposite page:
Living Texans / Hendrick–Long / Encino Press

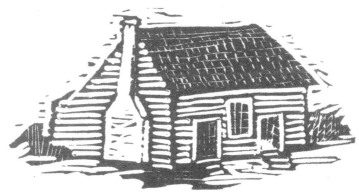

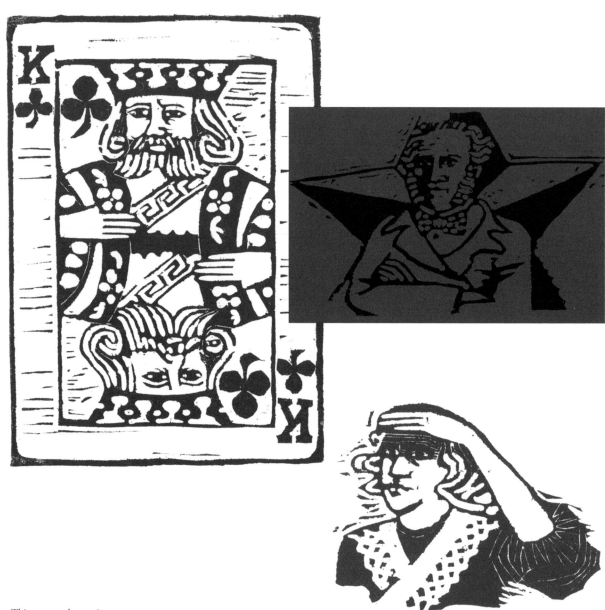

This page and opposite page:
Living Texans / Hendrick-Long / Encino Press

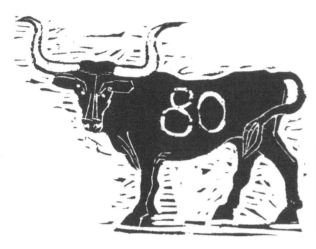

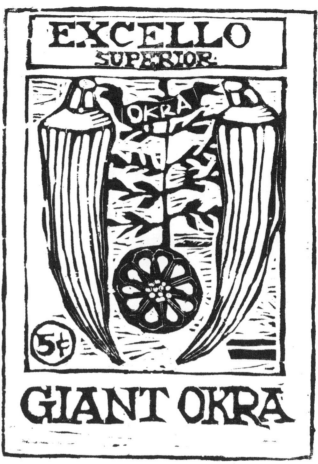

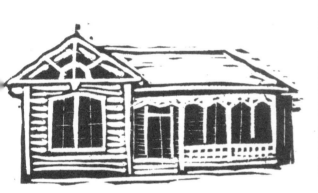

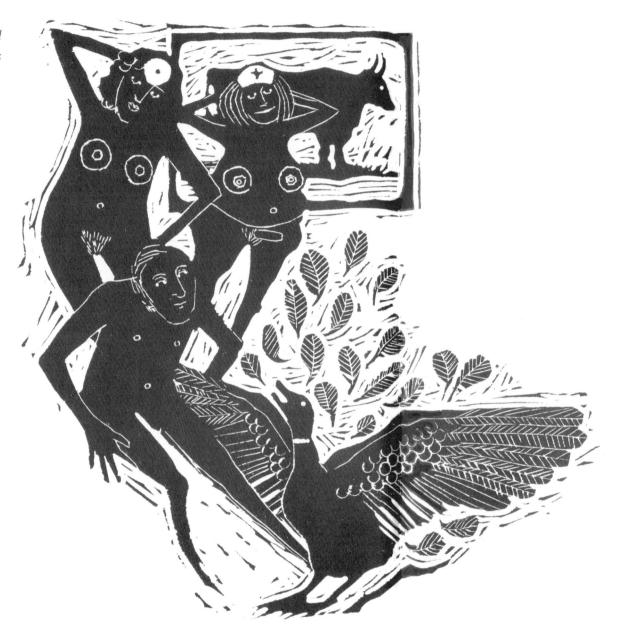

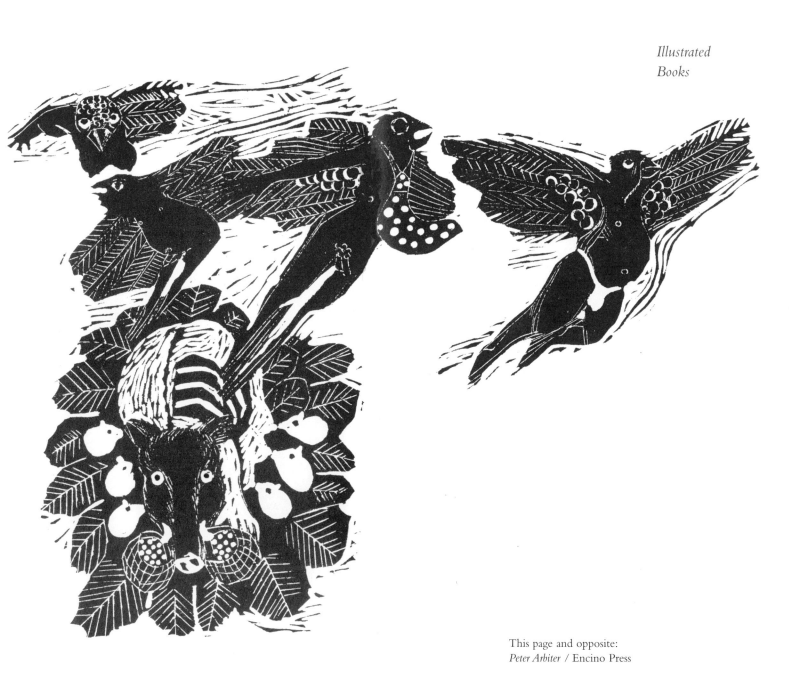

This page and opposite:
Peter Arbiter / Encino Press

Peter Arbiter / Encino Press

46

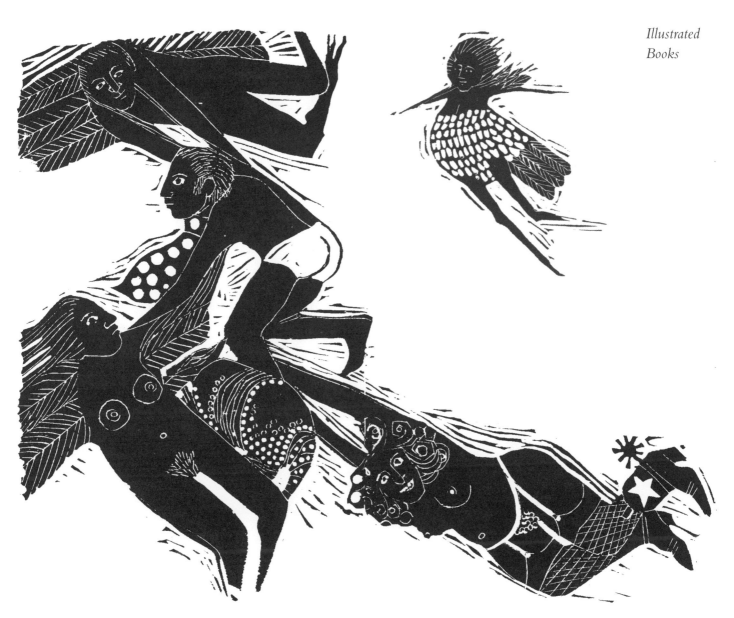

This page and opposite:
Peter Arbiter / Encino Press

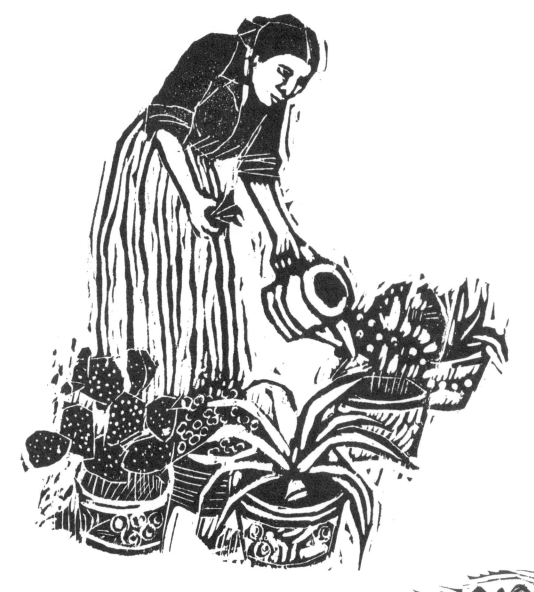

This page and Opposite page:
Cooking and Curing with Mexican Herbs /
Encino Press

48

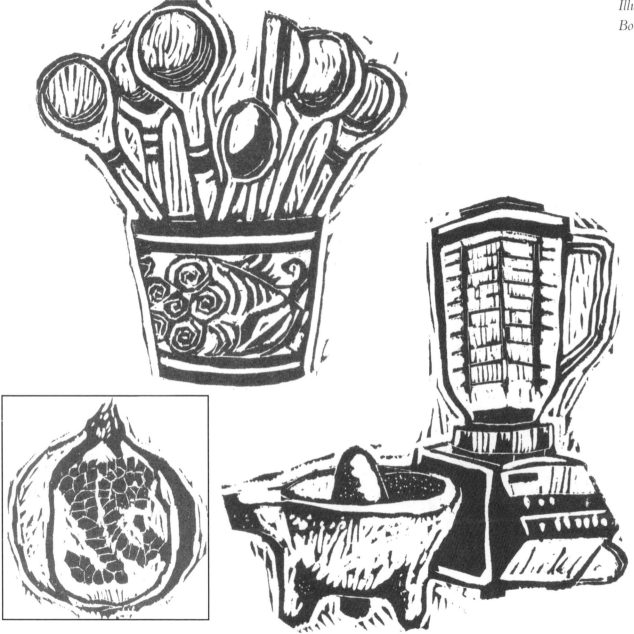

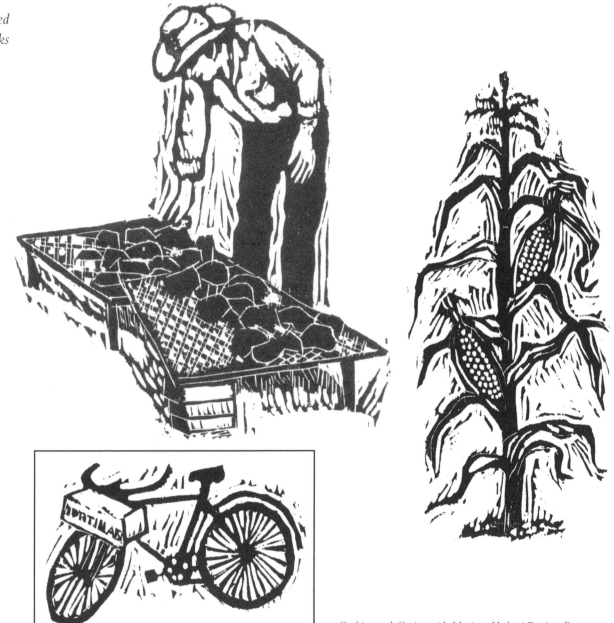

Cooking and Curing with Mexican Herbs / Encino Press

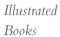

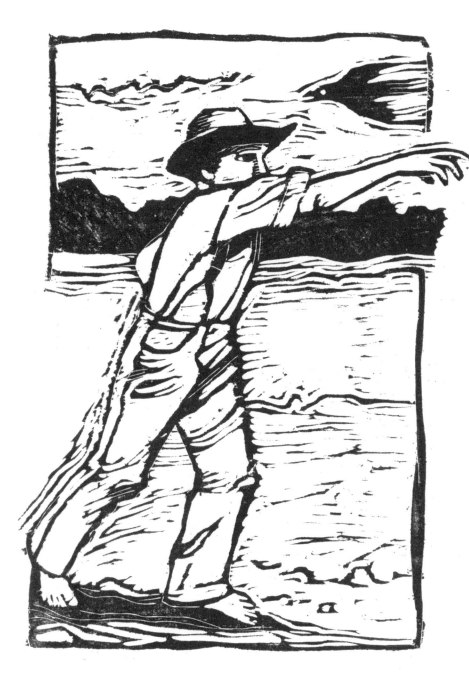

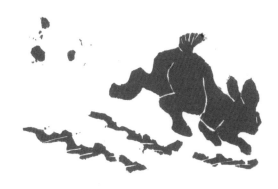

Just Such a Time / Kairos Press

51

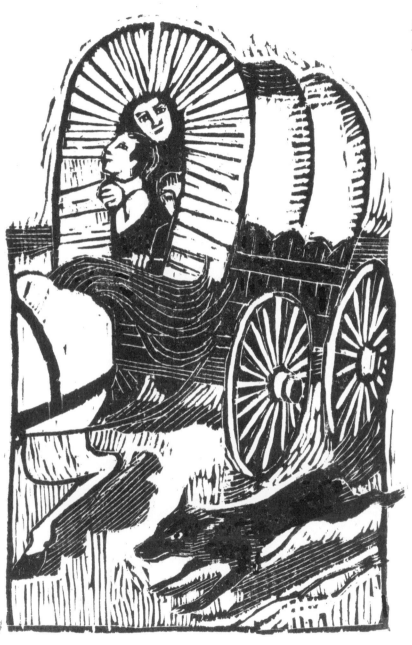

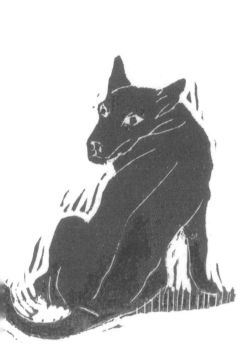

This page and opposite:
Just Such a Time / Kairos Press

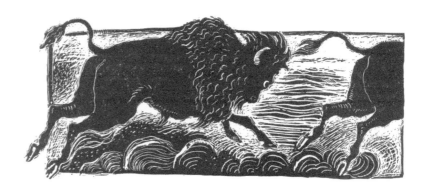

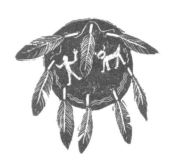

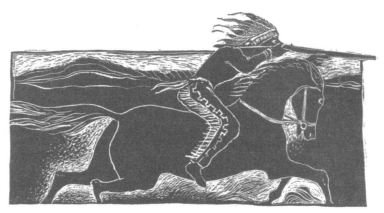

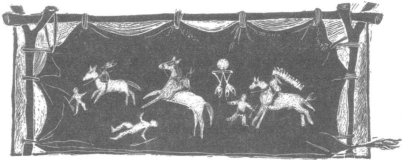

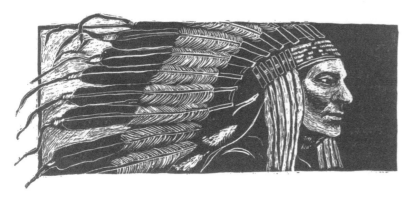

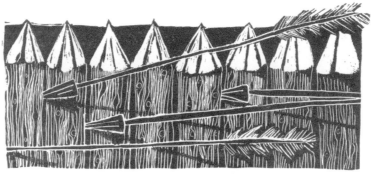

The Comanche Barrior to South Plains Settlement / Hardin Simmons University
*Note: These illustrations are executed on scratchboard to look like cuts. This technique
is done by scratching away black ink from a clay surfaced board to give a similar look to woodcuts.*

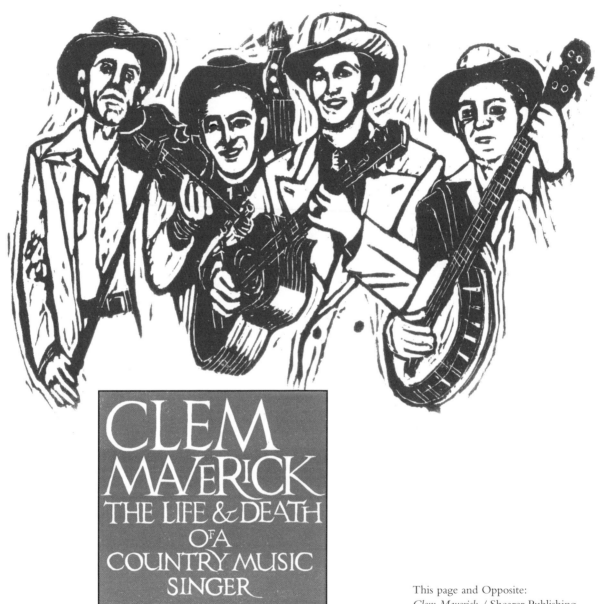

CLEM MAVERICK
THE LIFE & DEATH
OF A
COUNTRY MUSIC
SINGER

This page and Opposite:
Clem Maverick / Shearer Publishing

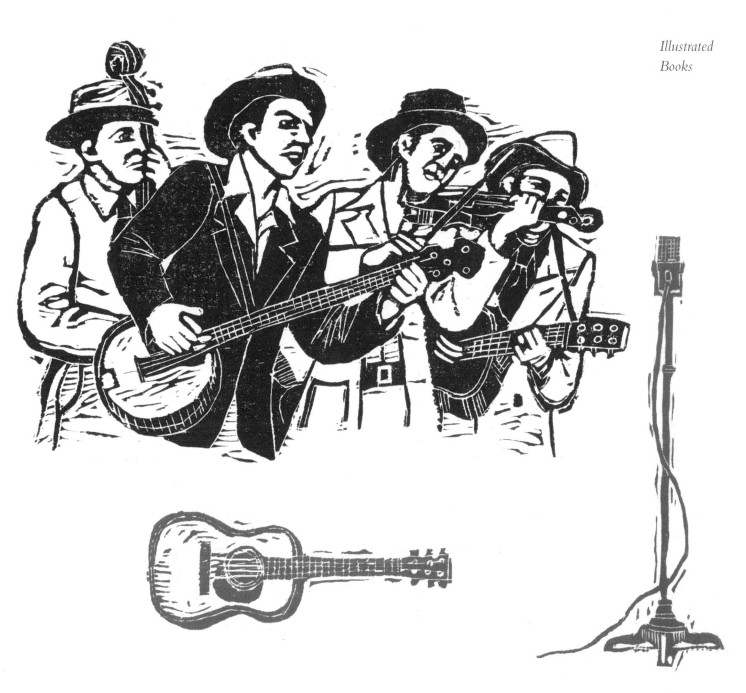

57

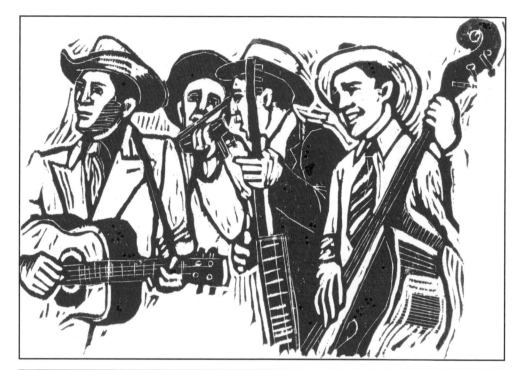

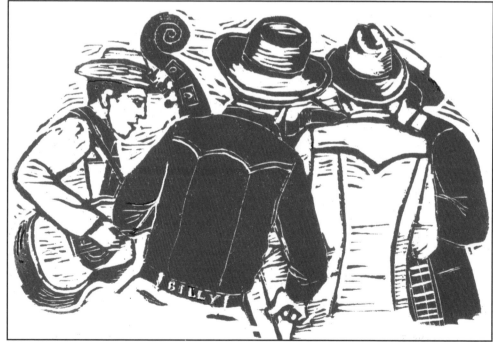

Clem Maverick /
Shearer Publishing

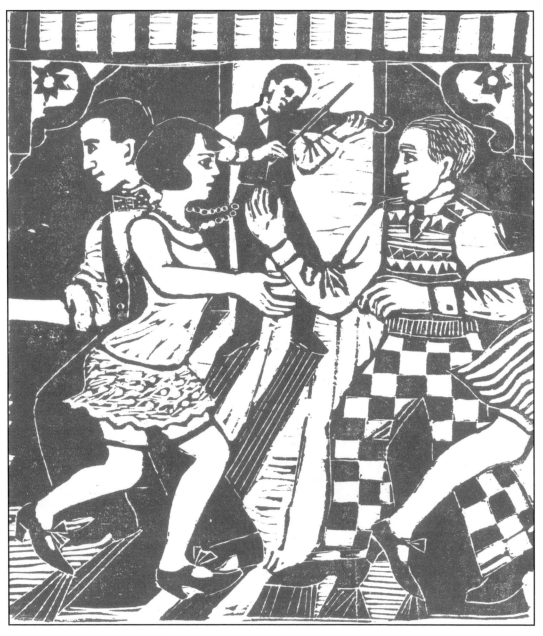

The Grands / The Book Club of Texas

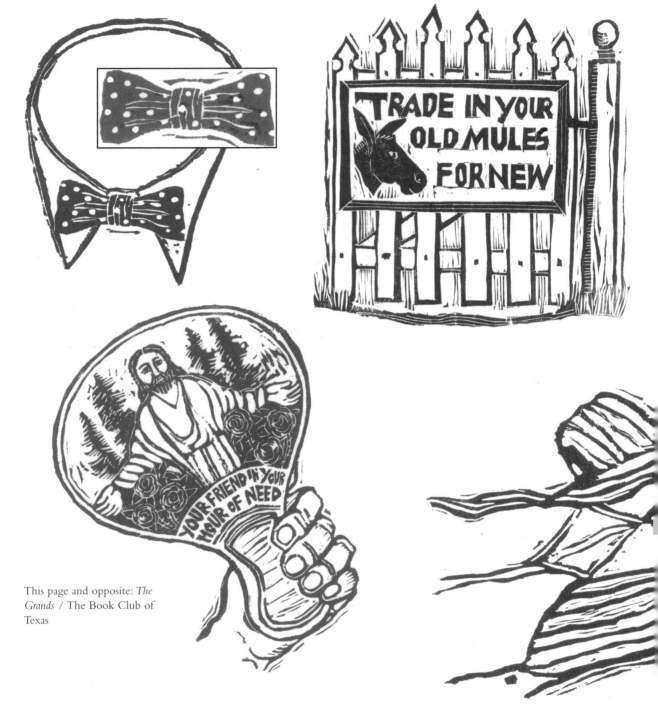

This page and opposite: *The Grands* / The Book Club of Texas

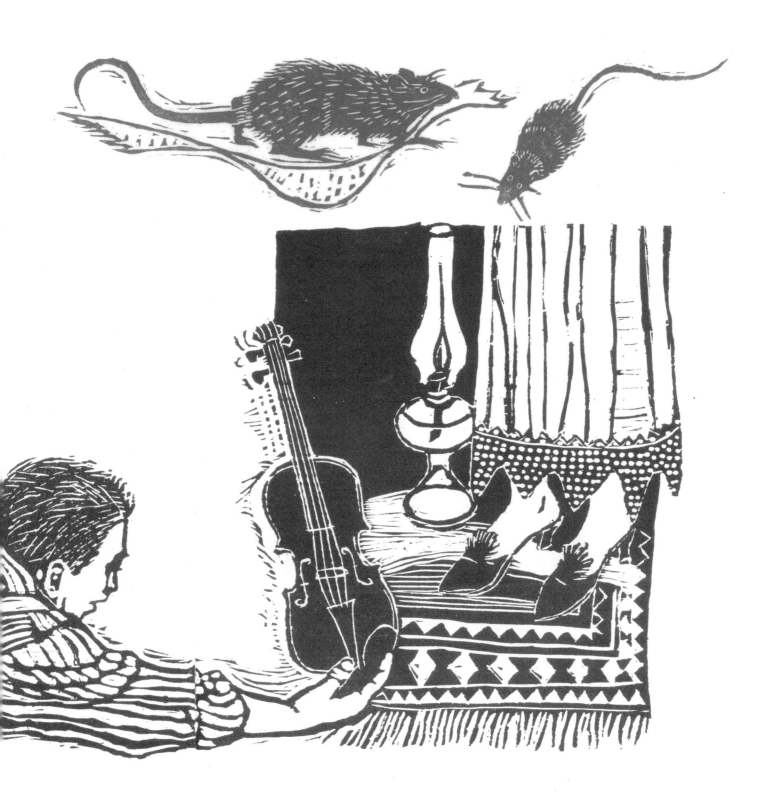

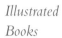

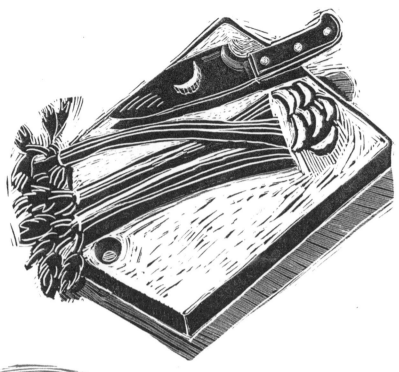

This page and opposite: Supper Time /
Winedale Publishing
(scratchboard)

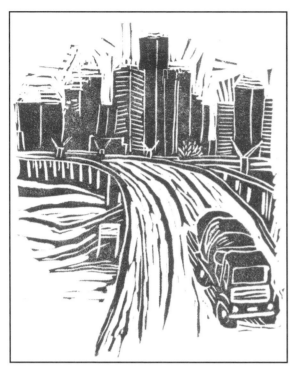

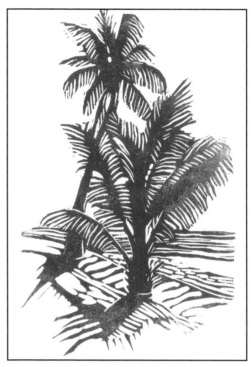

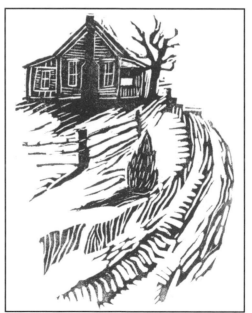

This page and opposite: *Touching Winter* / TCU Press

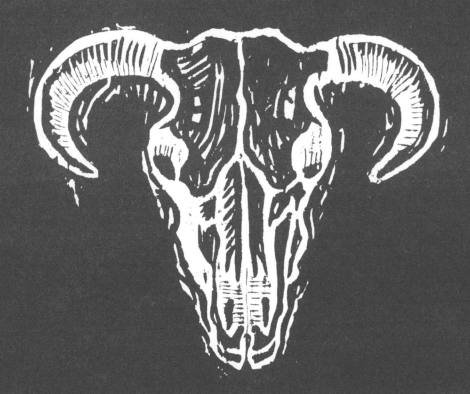

11 : Dustjackets *and* Covers

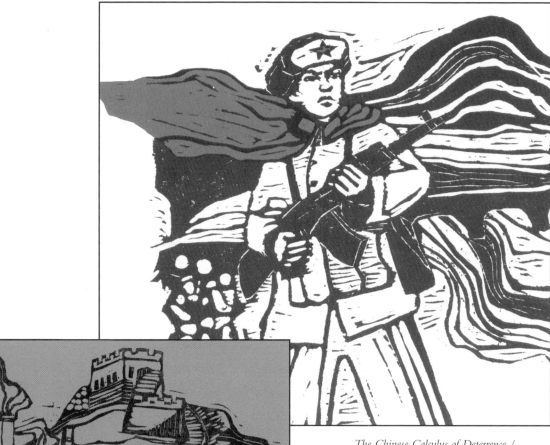

The Chinese Calculus of Deterrence /
University of Michigan Press

China's Economic Development /
University of Michigan Press

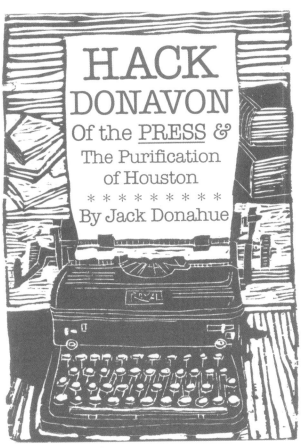

Hack Donavon of the PRESS / Shearer Publishing

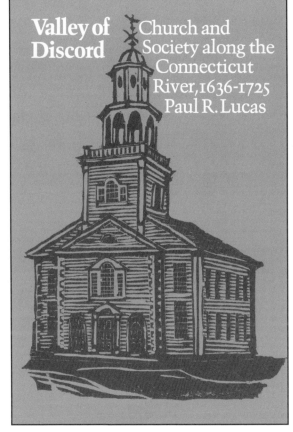

Valley of Discord / University Press of New England

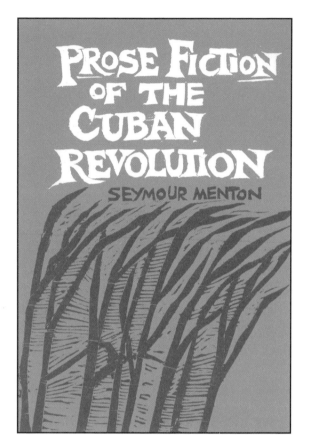

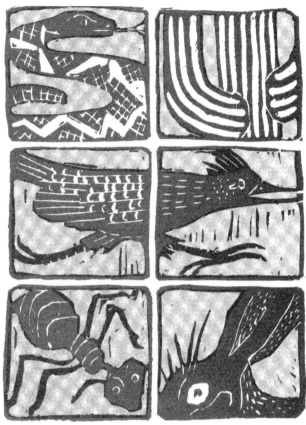

Clockwise:
*Prose Fiction of the Cuban
Revolution* / University of
Texas Press;
Desert Sancuary /
University of New
Mexico Press; *The
Economic Regulation of
Western Coal Transportation* /
Lyndon B. Johnson School
of Public Affairs

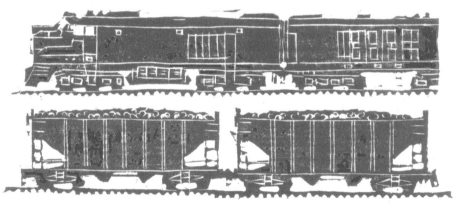

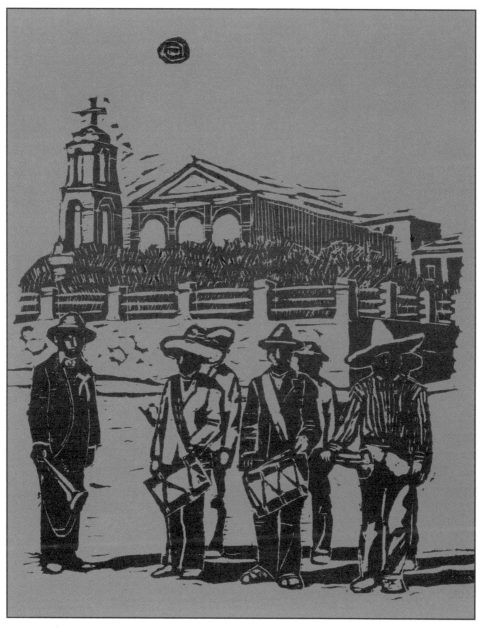

Border Boom Town / UT Press

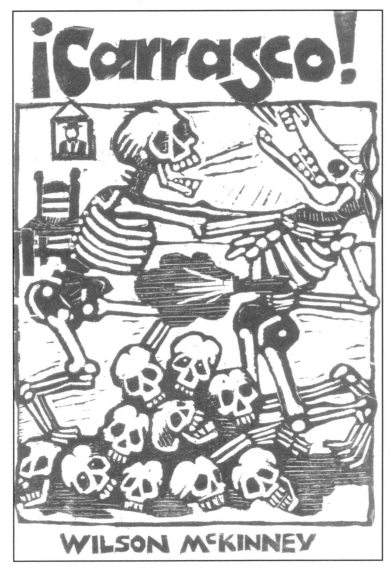

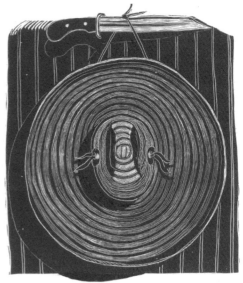

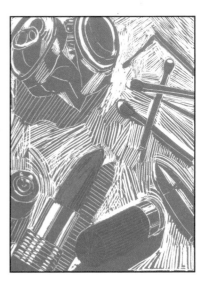

Above: *¡Carrasco!* / Heidelberg Publishers
Top right: *Rockspring* / SMU Press *(scratchboard)*
Right: *Desperate Measures* / SMU Press *(scratchboard)*

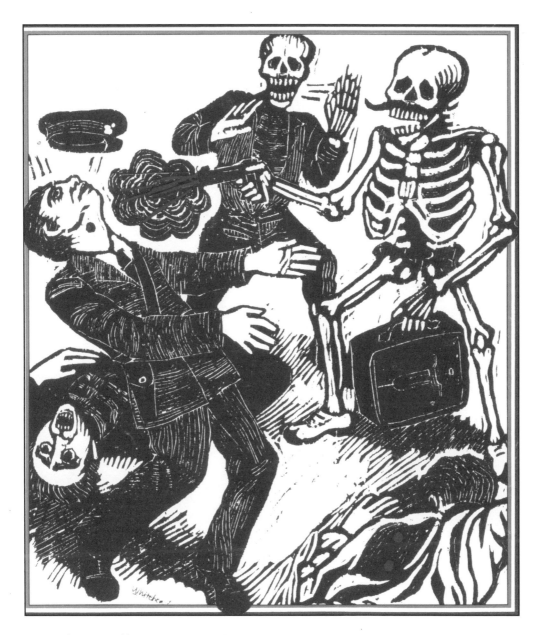

Cover of *Texas Monthly Magazine, August* 1973

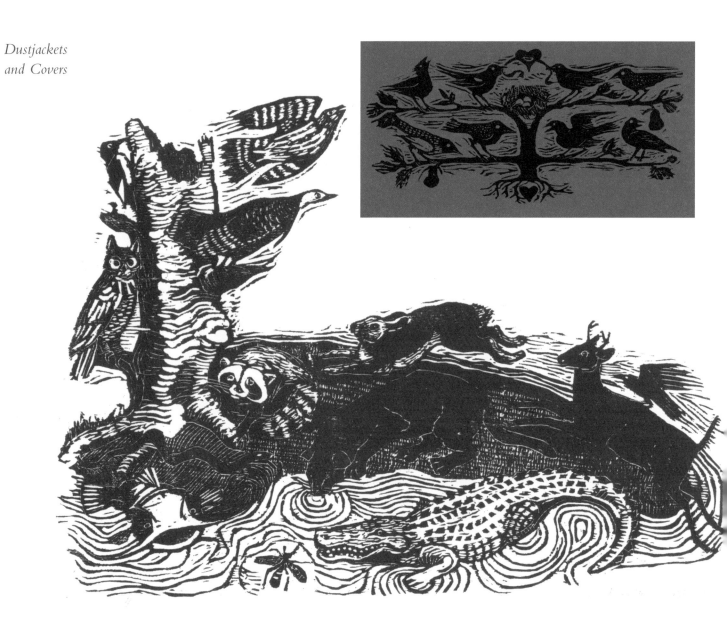

Top: *Poesy and Mirth* / Clearstream Press
Above: *Myths & Folktales of the Alabama-Coushatta Indians of Texas* / Encino Press

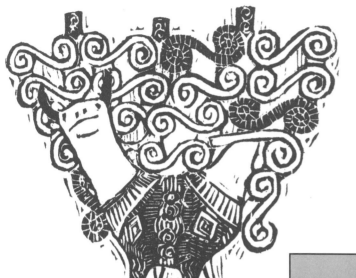

Left : The Pottery of Acatlán /
University of Oklahoma Press
Below: *Wildcatters: Texas Independent Oilmen /*
Texas Monthly Press

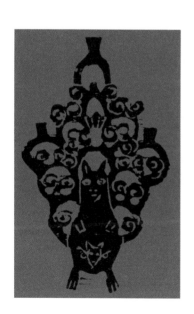

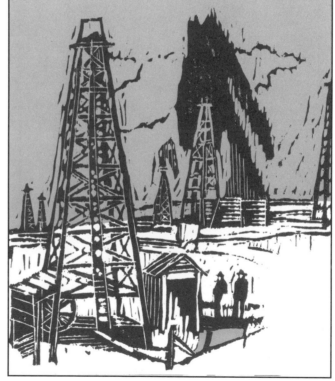

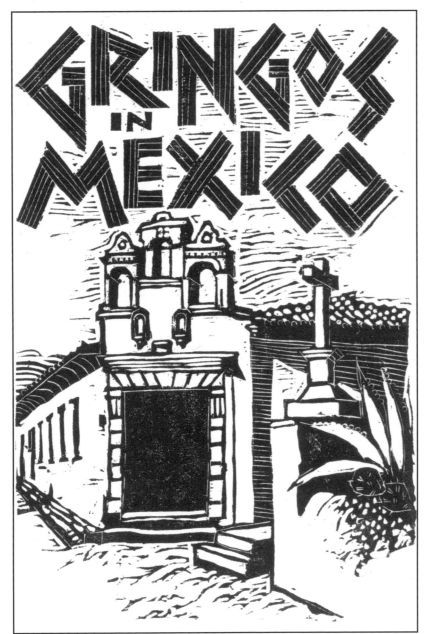

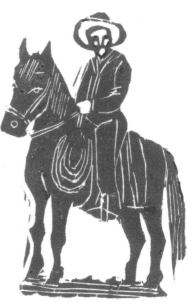

Gringos in Mexico / TCU Press

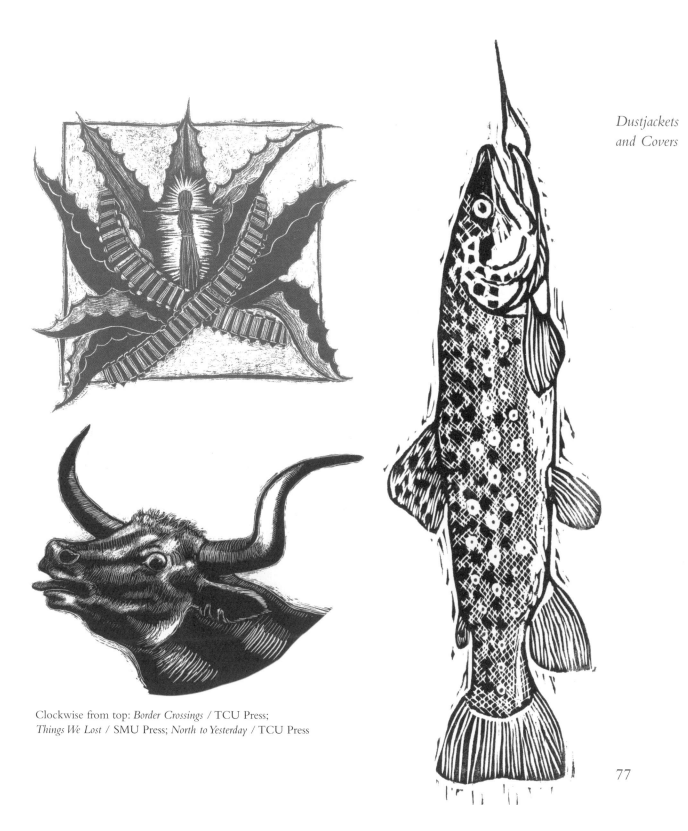

Clockwise from top: *Border Crossings* / TCU Press;
Things We Lost / SMU Press; *North to Yesterday* / TCU Press

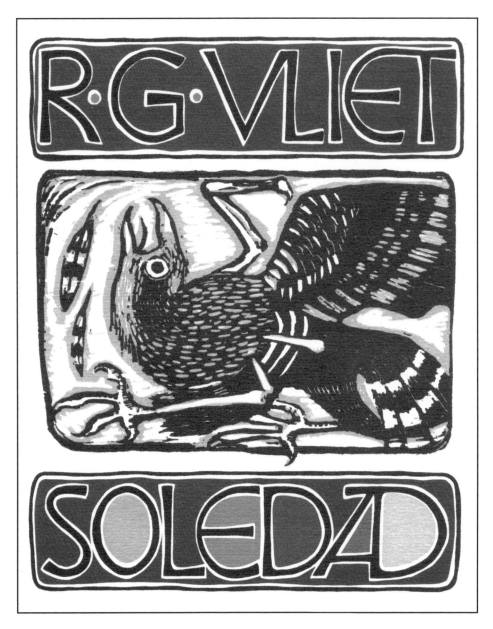

Solidad or Solitudes / TCU Press

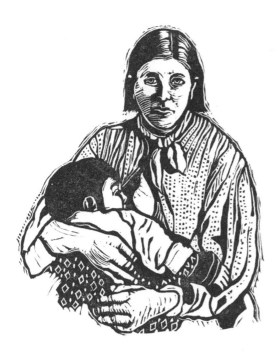

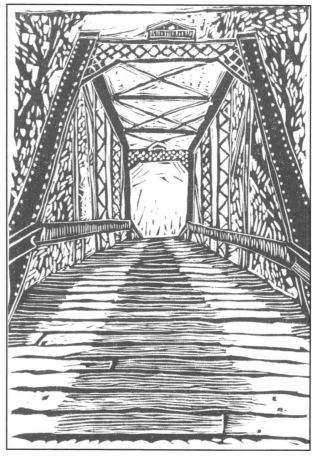

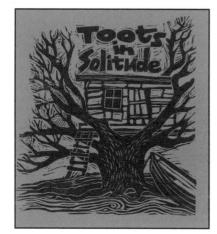

Clockwise from top: *Killing Cynthia Ann* / TCU Press;
High John the Conquerer / TCU Press; *Thin Men of
Haddam* / TCU Press; *Toots in Solitude* / SMU Press

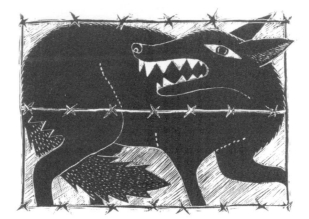

79

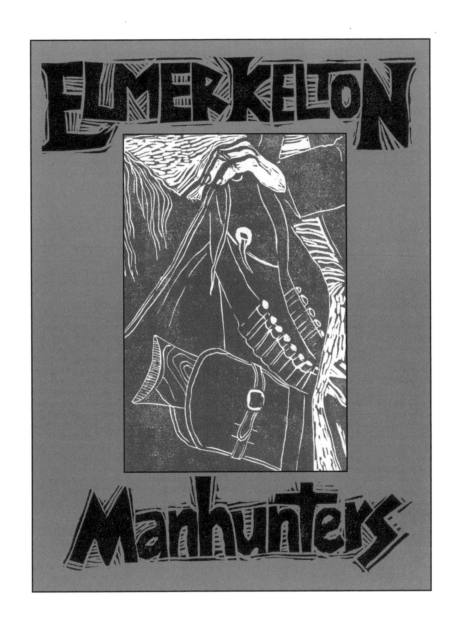

Manhunters / TCU Press

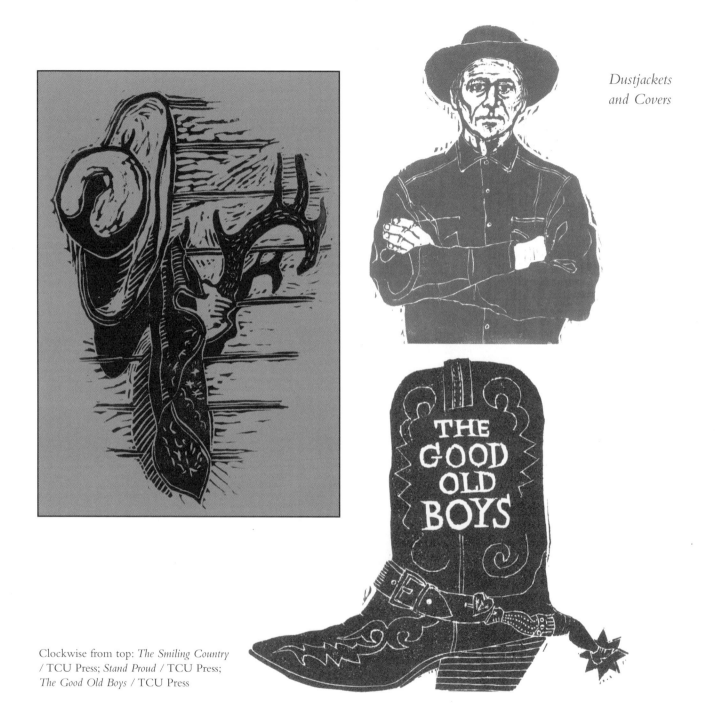

Clockwise from top: *The Smiling Country* / TCU Press; *Stand Proud* / TCU Press; *The Good Old Boys* / TCU Press

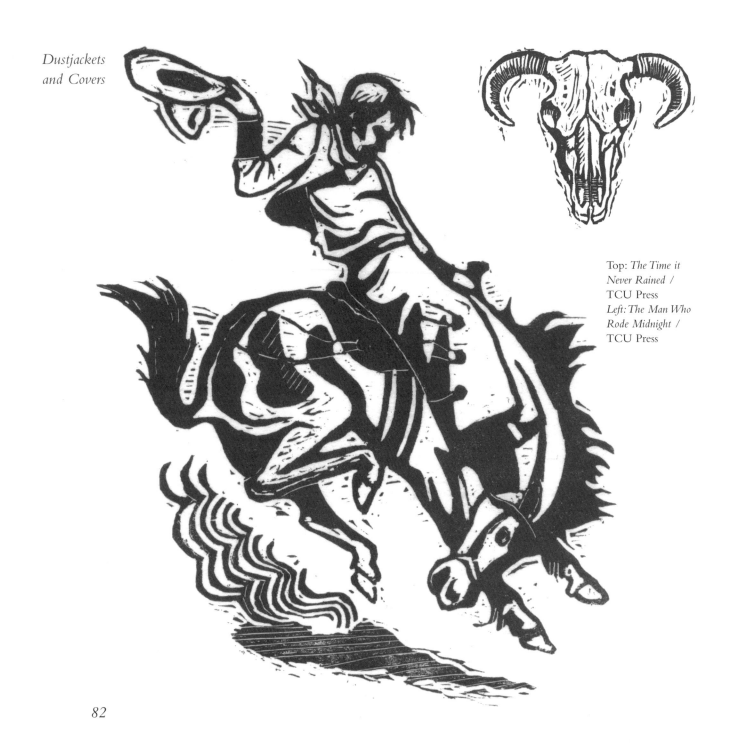

Top: *The Time it
Never Rained /
TCU Press*
Left: *The Man Who
Rode Midnight /
TCU Press*

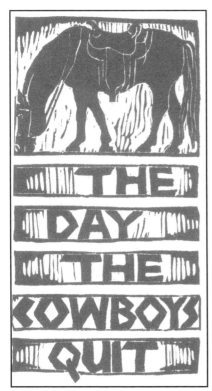

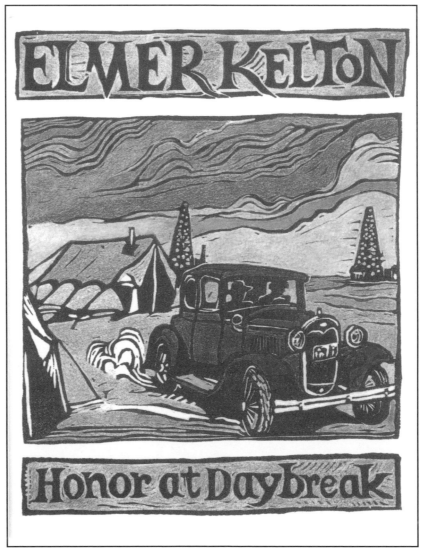

Cockwise from top left:
The Day the Cowboys Quit / TCU Press
Honor at Daybreak / TCU Press
Wagontongue / TCU Press

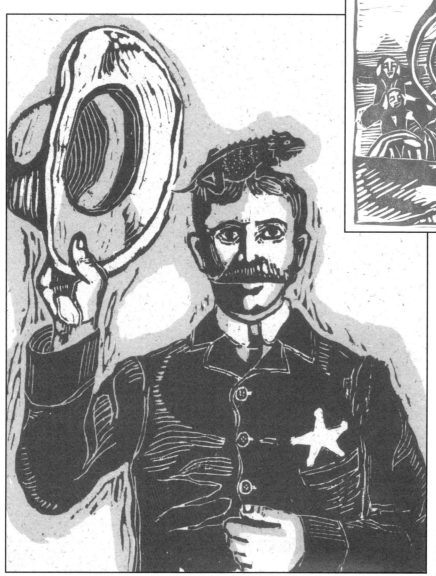

Left: *O'Henry's Texas Stories /*
Still Point Press
Top right: *Mexicans at Arms /*
TCU Press

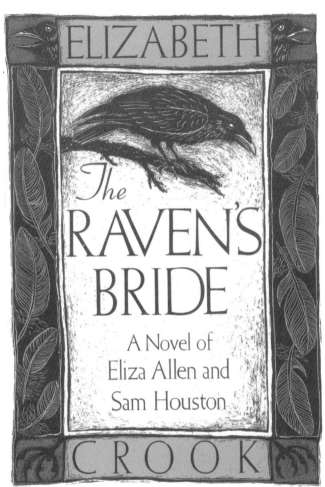

ELIZABETH

The
RAVEN'S
BRIDE

A Novel of
Eliza Allen and
Sam Houston

CROOK

Clockwise from left: Earth Horizon / University of New Mexico Press; The Raven's Bride / SMU Press; Gaining Ground in College Writing /SMU Press (this page all scratch-board)

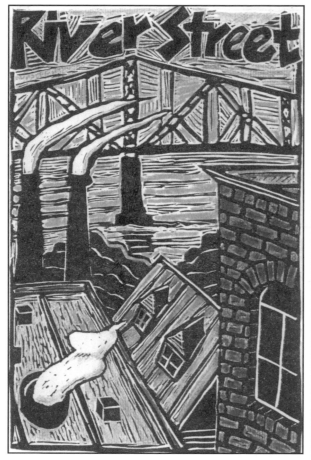

River Street / SMU Press

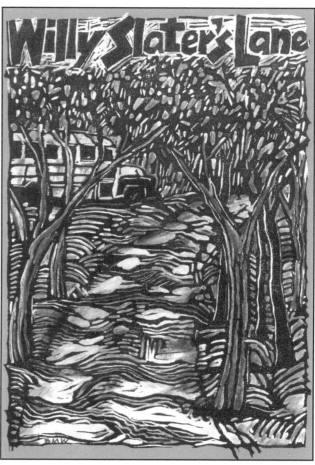

Willy Slater's Lane / SMU Press

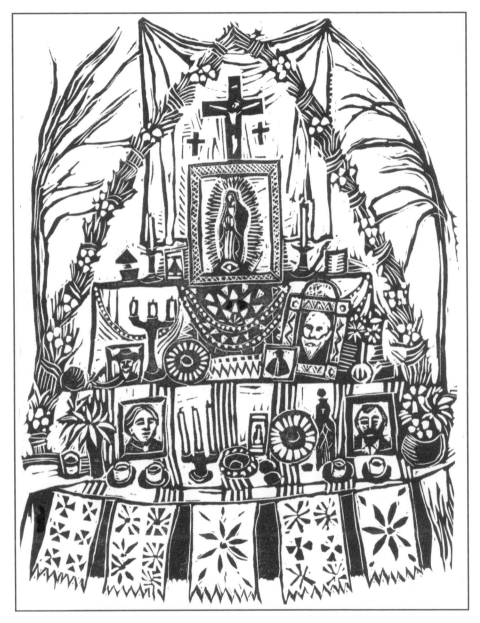

The Tejano Community, 1836-1900 / SMU Press

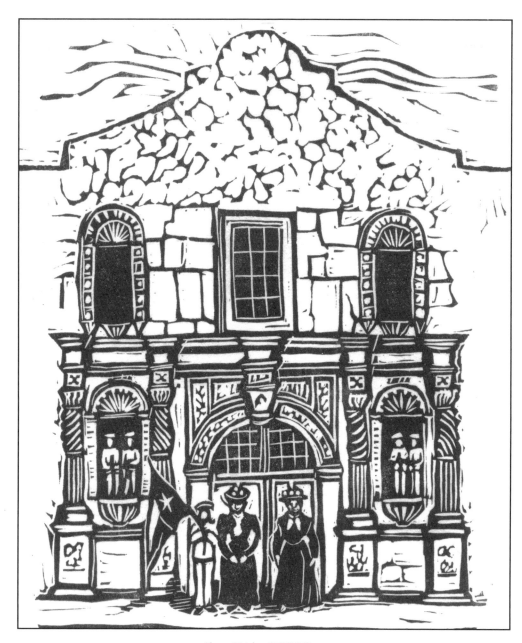

Alamo Heights / TCU Press

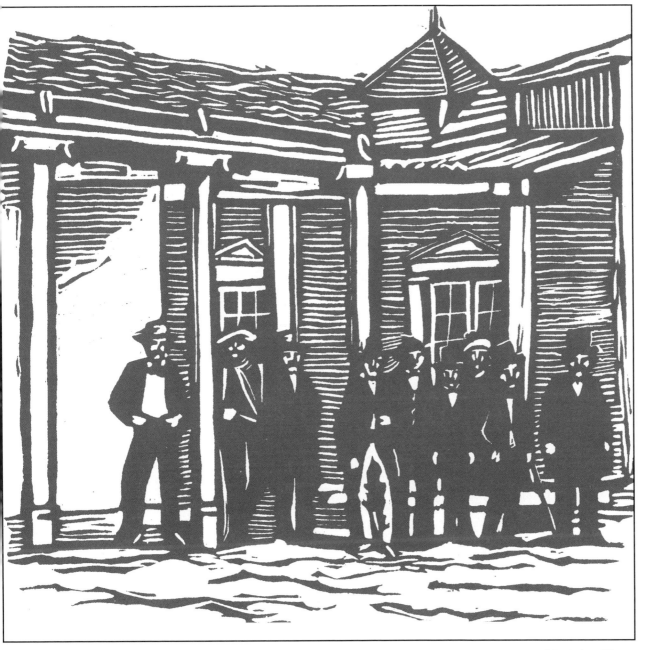

Trading In Santa Fe / SMU Press and DeGolyer Library

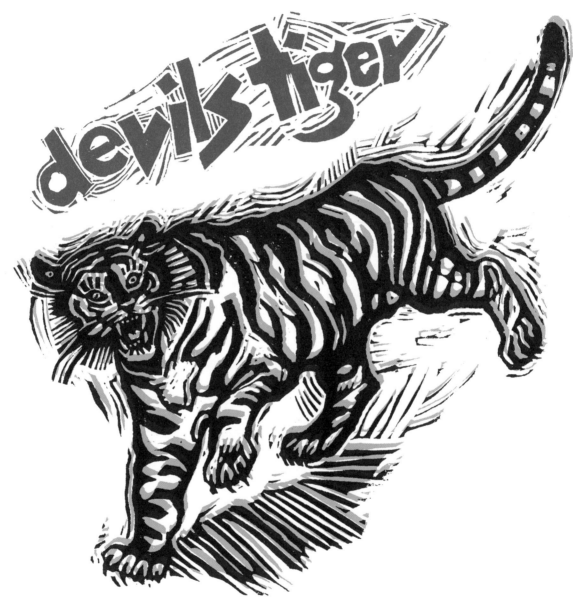

Devils Tiger / TCU Press

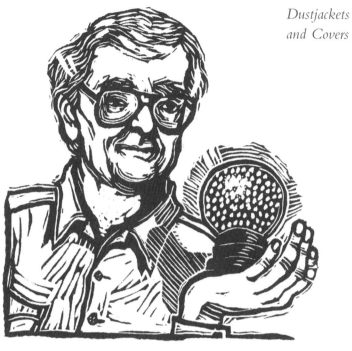

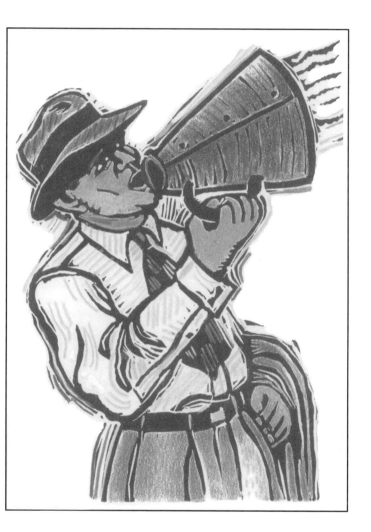

Above: *Memory of Snow* / Browder Springs
Right: *The One-Eyed Man* / TCU Press

This Stubborn Self / TCU Press

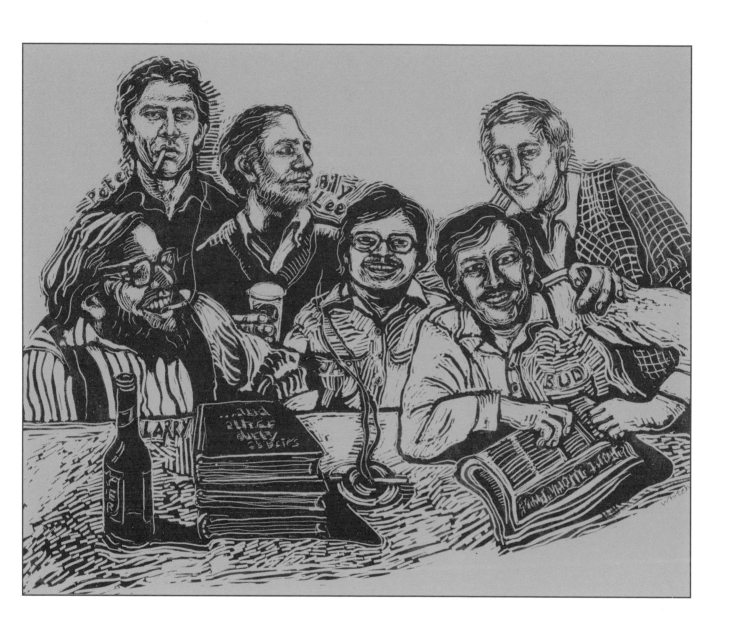

Texas Litersary Outlaws / TCU Press (scratchboard)

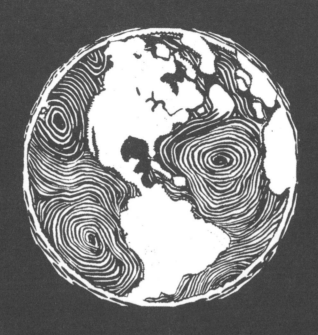

III : Commissions &
Spot Illustrations

Clockwise from left: *Christmas in Troubled Times* / Friends of Winedale; *Remembering Dudley Dobie: The First Bookseller to Enrich My Life and Empty My Pockets.* / The Lagarto Press; *Chronicles of Fayette* / Privately printed

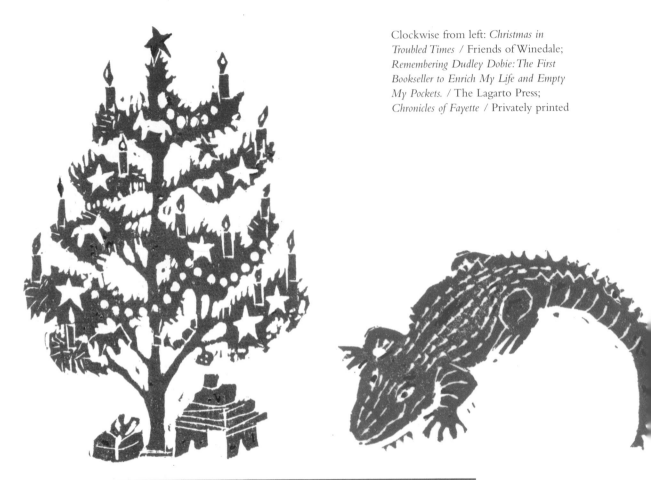

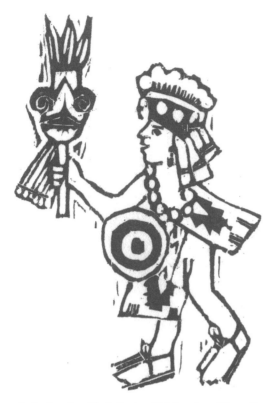

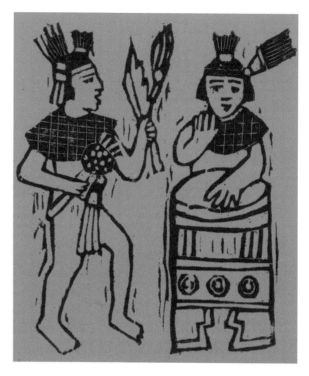

Latin American Music Review / University of Texas Press

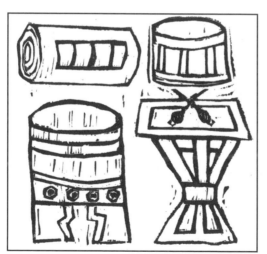

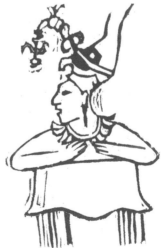

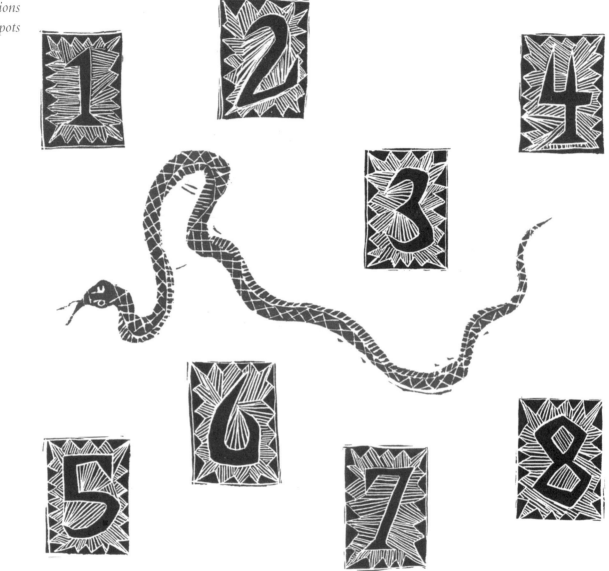

Always a Rebel / TCU Press

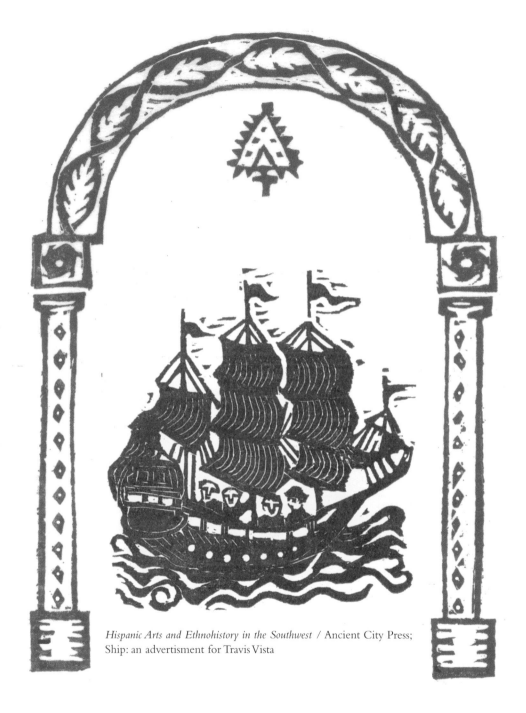

Hispanic Arts and Ethnohistory in the Southwest / Ancient City Press;
Ship: an advertisment for Travis Vista

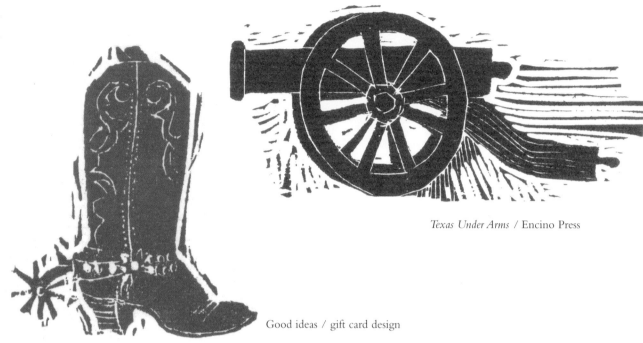

Texas Under Arms / Encino Press

Good ideas / gift card design

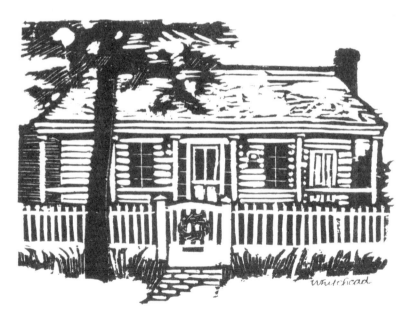

San Augustine in the Texas Republic /
Edward and Anne Clark

100

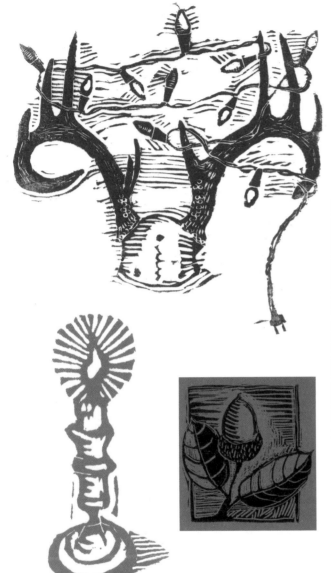

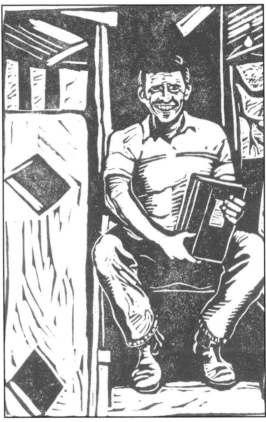

Christmas in Troubled Times /
Winedale Museum

Remembering Bill / privately printed tribute to Bill Shearer

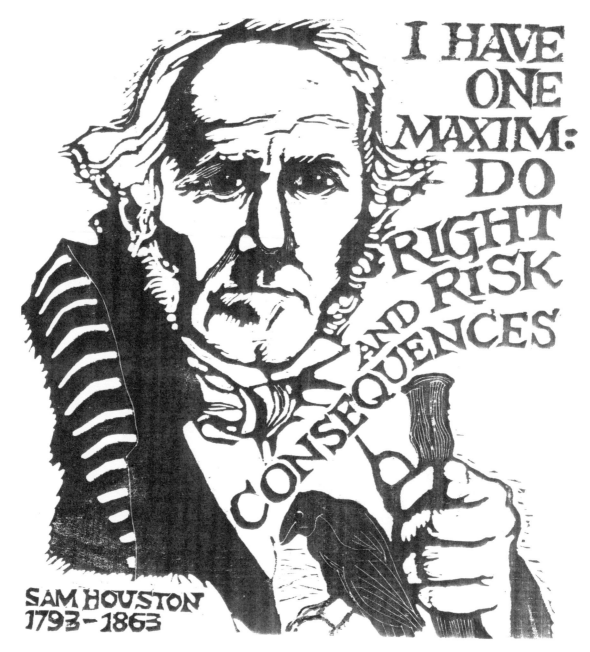

I HAVE ONE MAXIM: DO RIGHT RISK AND CONSEQUENCES

SAM HOUSTON 1793–1863

Encino Press broadside

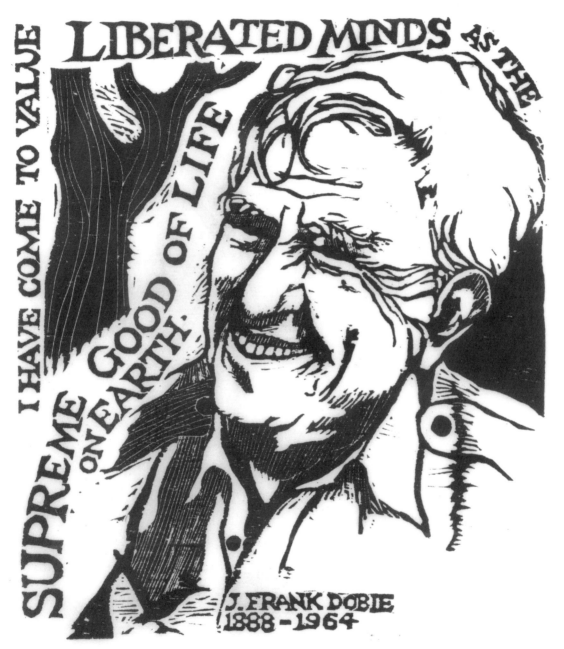

I HAVE COME TO VALUE LIBERATED MINDS AS THE SUPREME GOOD OF LIFE ON EARTH.

J. FRANK DOBIE
1888-1964

Encino Press broadside

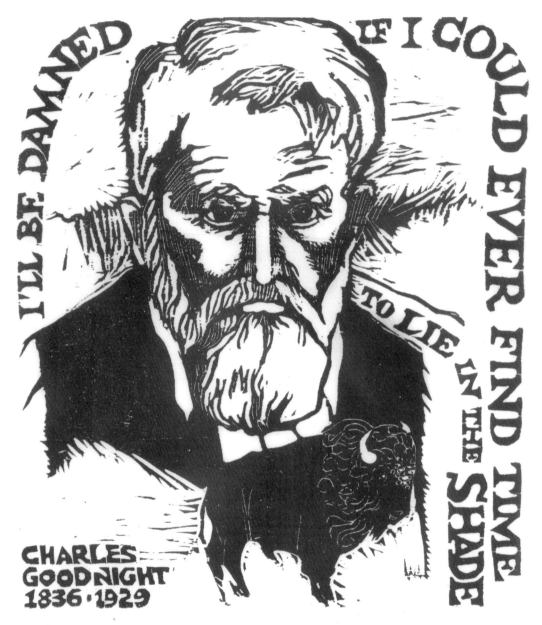

I'LL BE DAMNED IF I COULD EVER FIND TIME TO LIE IN THE SHADE

CHARLES GOODNIGHT 1836·1929

Encino Press broadside

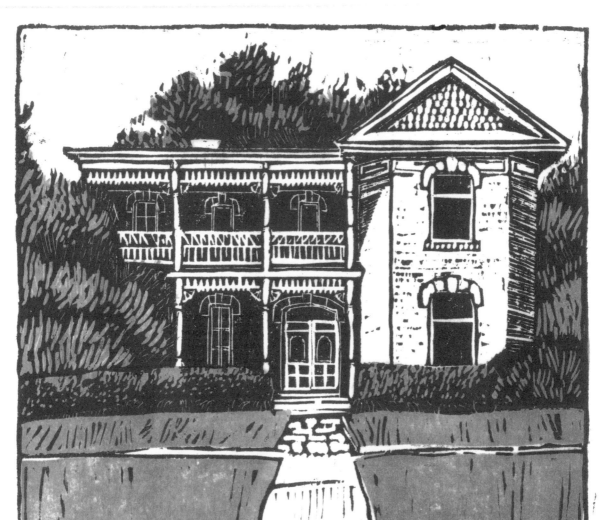

Encino Press office

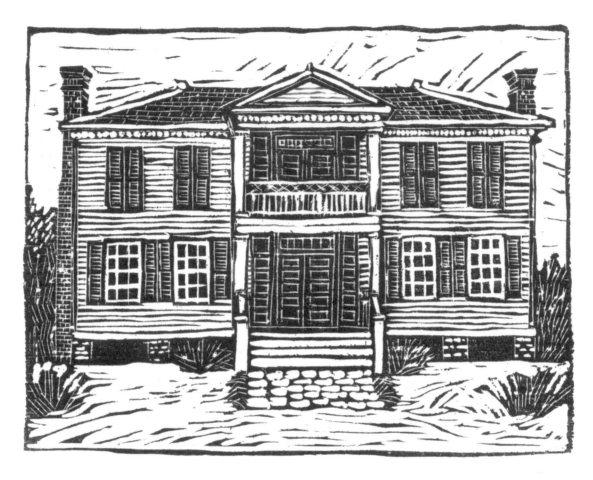

Winedale Historical Museum, McGregor-Grimm House

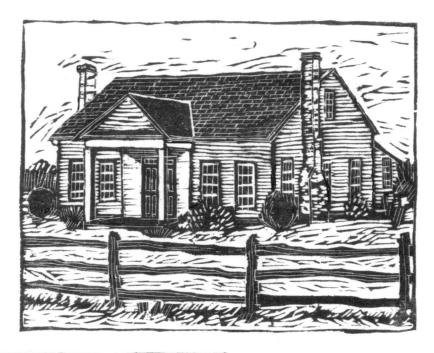

Winedale Historical
Museum, Lauderdale
House, above; Hazel's
Lone Oak, left

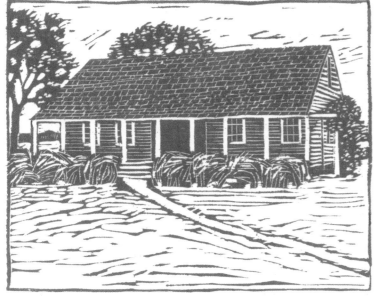

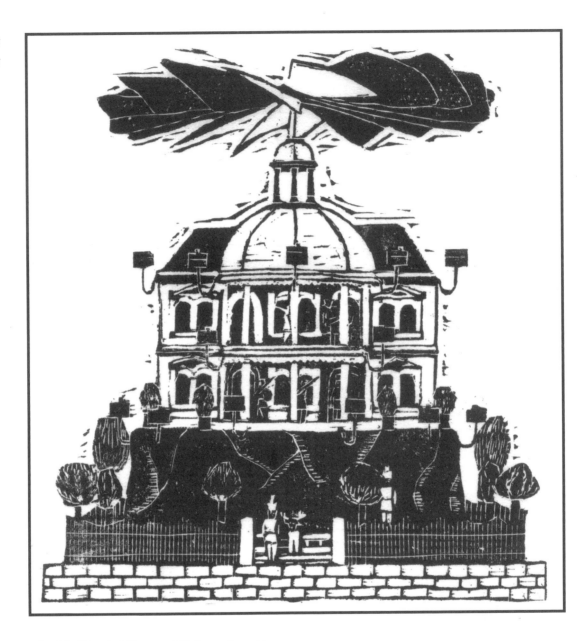

Winedale Historical Museum / Christmas Pyramide

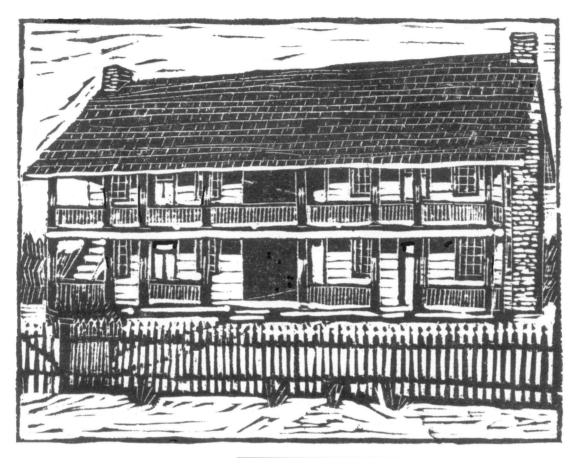

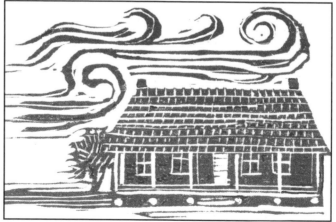

Above: Winedale Historical Museum,
Lewis House; Right: *Christmas in Troubled
Times* / Winedale Museum

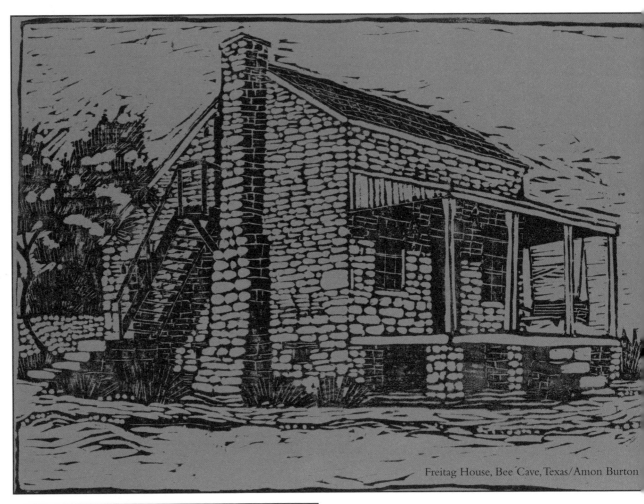

Freitag House, Bee Cave, Texas/Amon Burton

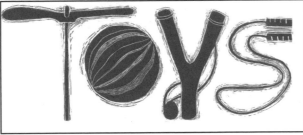

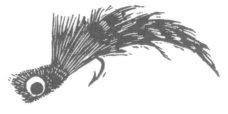

Left: *Texas Toys and Games* / *SMU Press*
Above: *Fly-fishing the Texas Hill Country* / W. Thomas Taylor

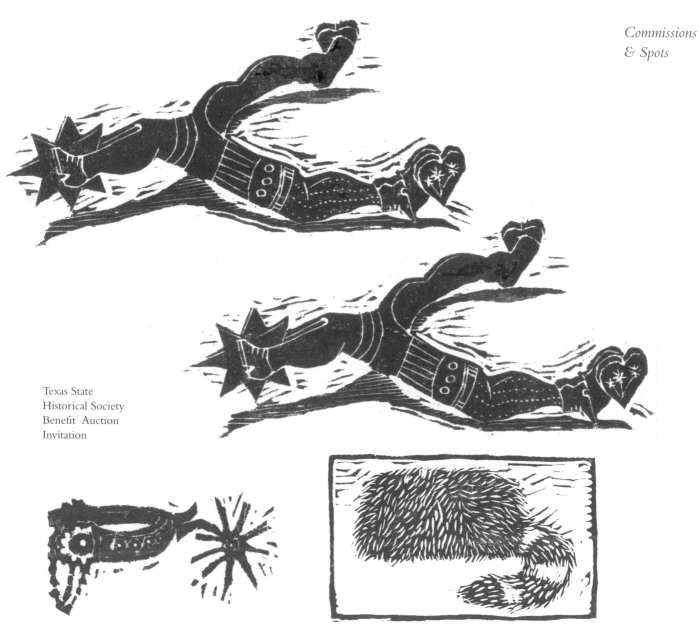

Texas State
Historical Society
Benefit Auction
Invitation

Good Ideas / card design

Bob Bullock State History History Museum,
Davey Crockett Exhibition

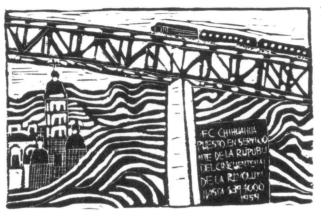

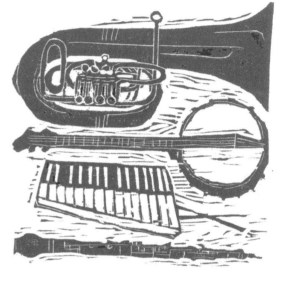

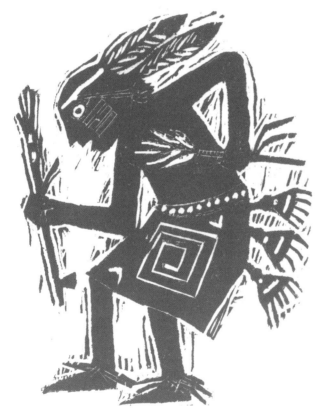

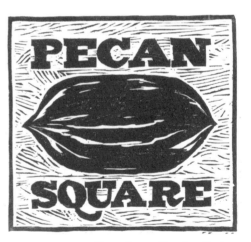

Pecan Square Sopping Center

112

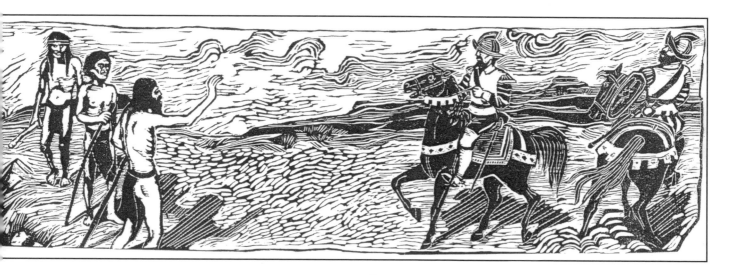

Texas State University / Southwestern Writers Collection

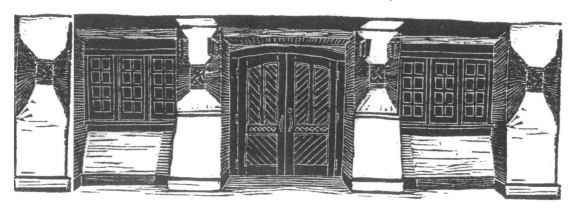

 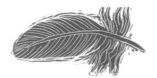 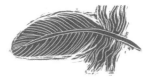

Raven's Bride / SMU Press

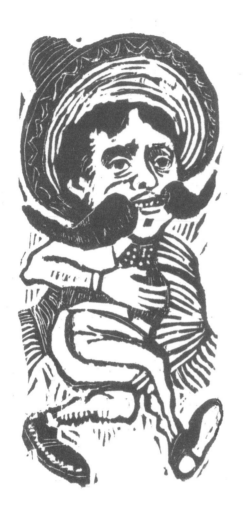

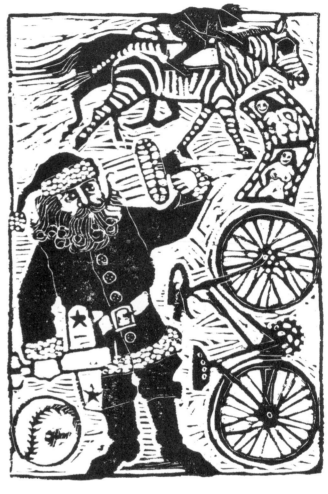

Texas Monthly Magazine

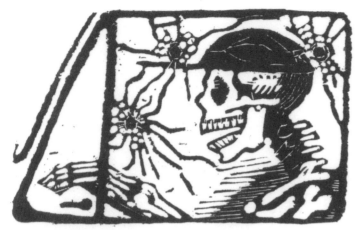

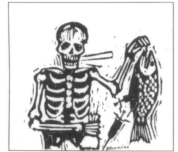

Texas Monthly Magazine

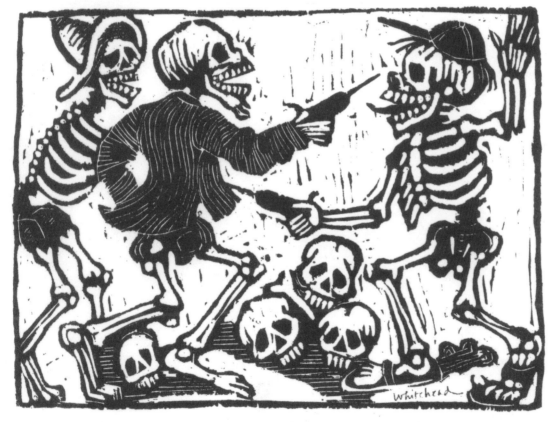

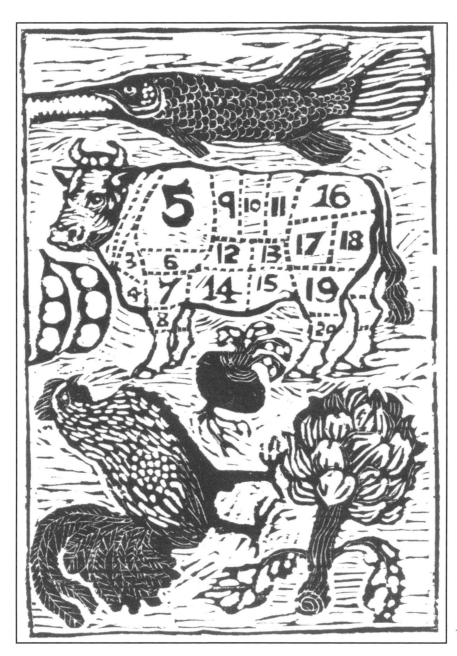

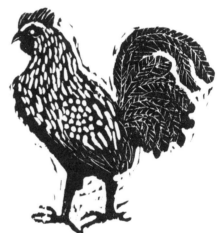

Texas Monthly Magazine

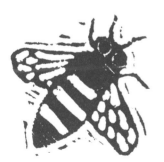

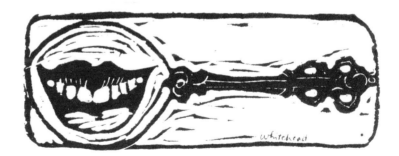

117

Commissions
& Spots

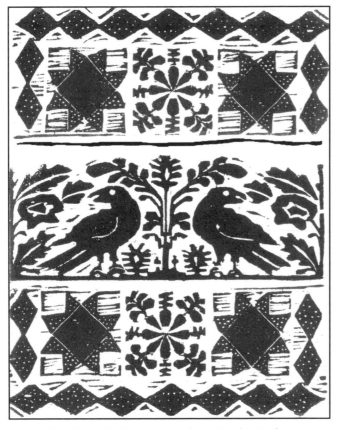

Star of the Republic Museum / *Quilts & Coverlets* Catalog

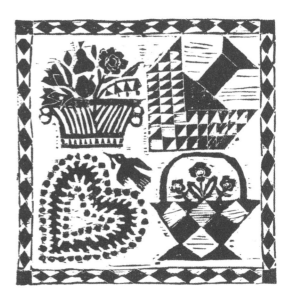

Above: *Fredericksburg, Texas* / Shearer Publishing
Below: *Texas Monthly Magazine*

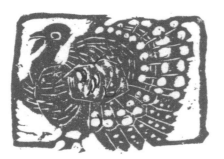

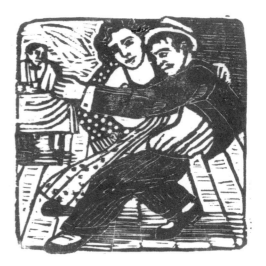

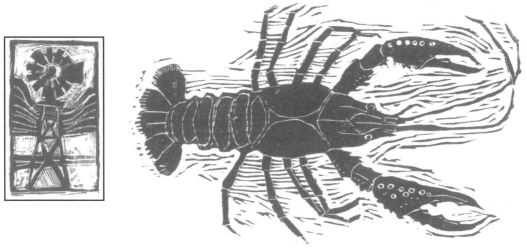

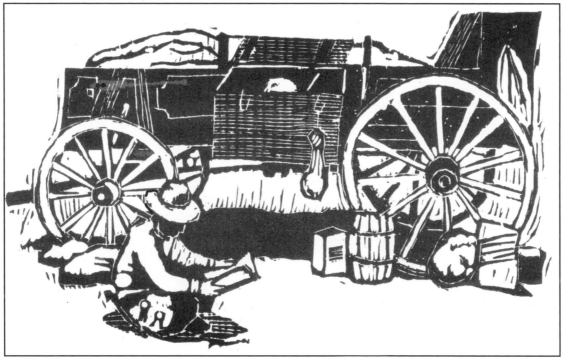

Top right: *Village Creek* / Shearer Publishing; Above: *Books on Texas and the West* Catalog / University of Texas Press, 1978

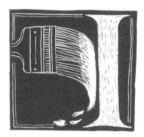

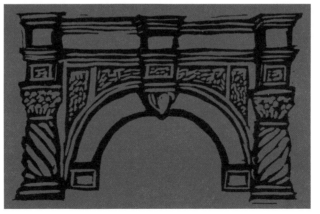

Above: *Warriors and Maidens* /
TCU Press (scratchboard)

Saving San Antonio / Texas
Tech University Press

*Commissions
& Spots*

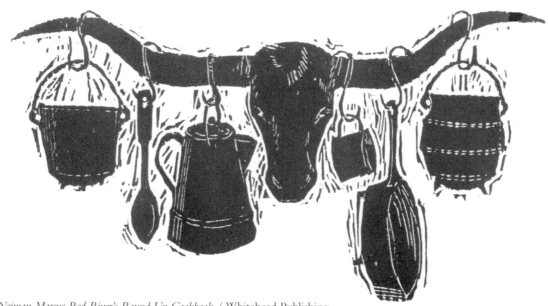

Neiman-Marcus Red River's Round Up Cookbook / Whitehead Publishing

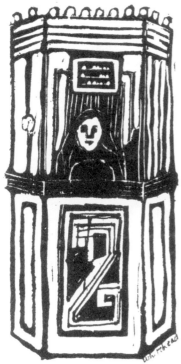

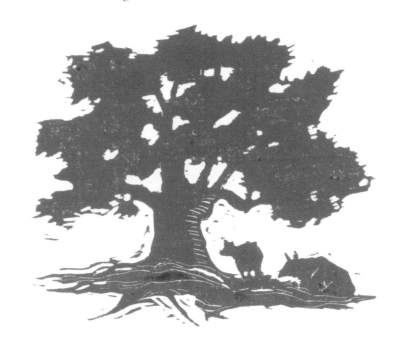

Texas Monthly Magazine

121

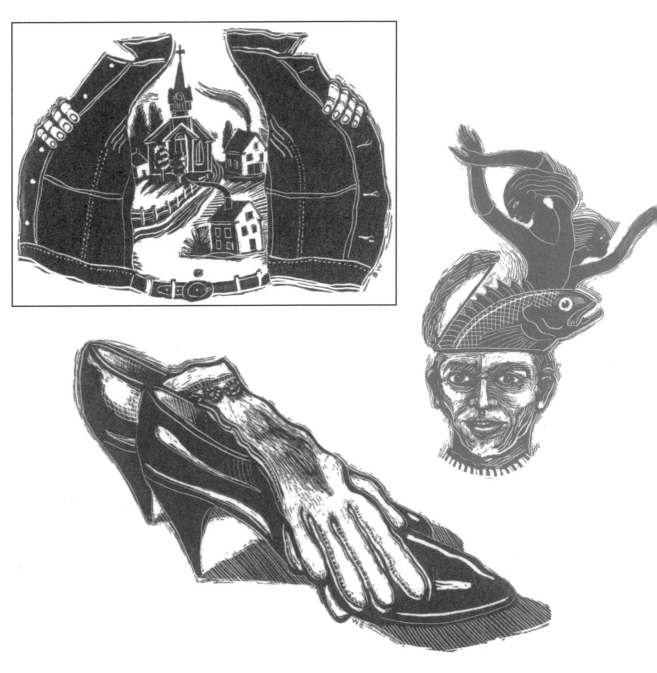

122

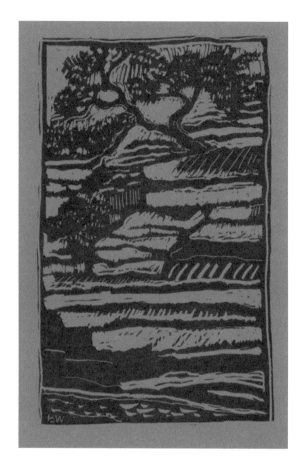

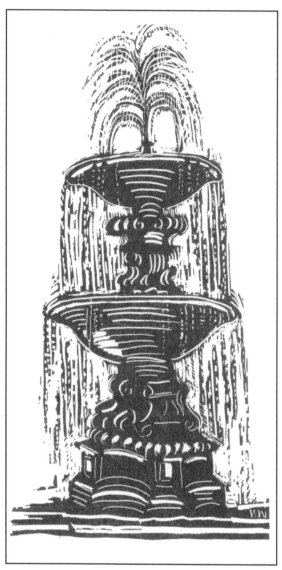

Barnes and Noble broadsides:
Quotes by A.C. Greene,
Marshall Terry, Prudence
Macintosh, John Graves,
Stanley Marcus

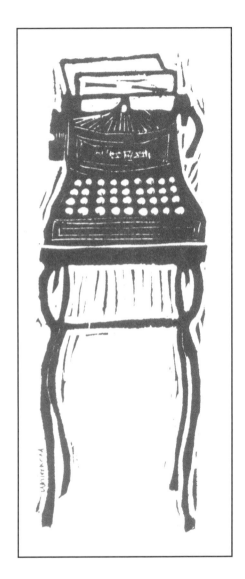

Above: *Texas Monthly Magazine*
Right: *A Reference Guide to Texas Law & Legal History* / UT Press

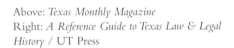

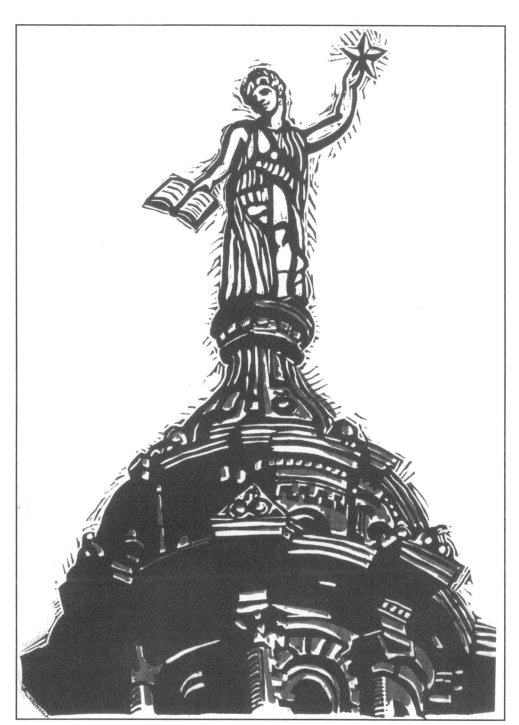

Texas Book Festival Poster, 1999

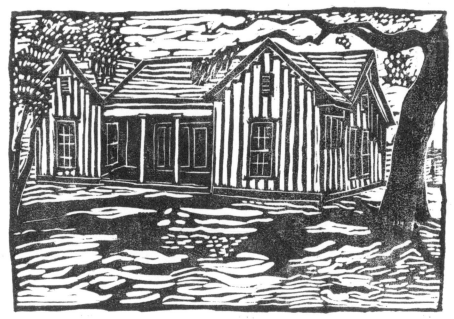

Left: Lowman Library,
San Marcos
Below left: First United
Methodist Church, San
Marcos for Al lowman

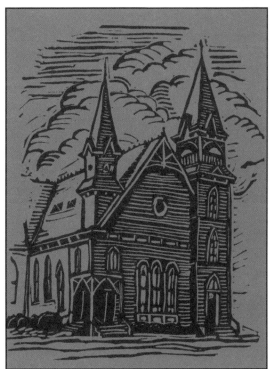

Alison and Whit Hanks / Folly

126

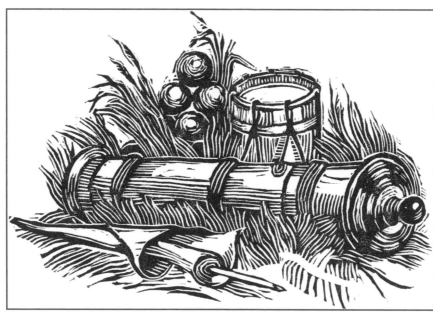

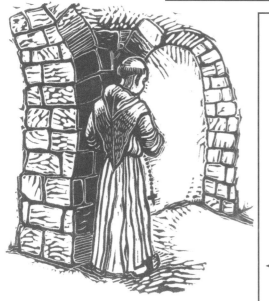

Alamo Exhibit / San Antonio

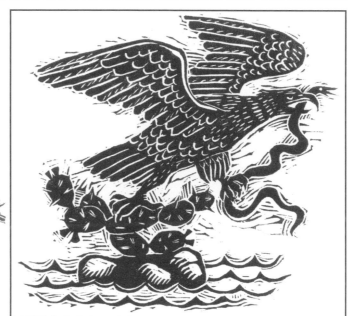

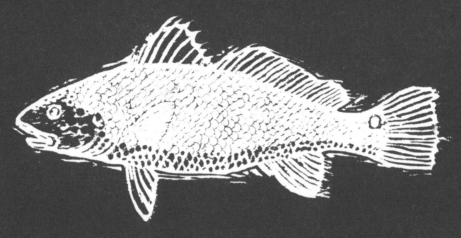

IV: Personal Work

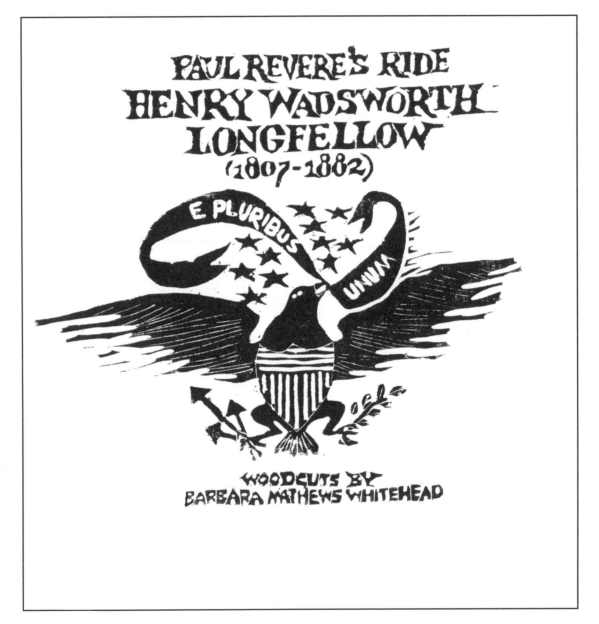

Book project for UT class / *Paul Revere's Ride*

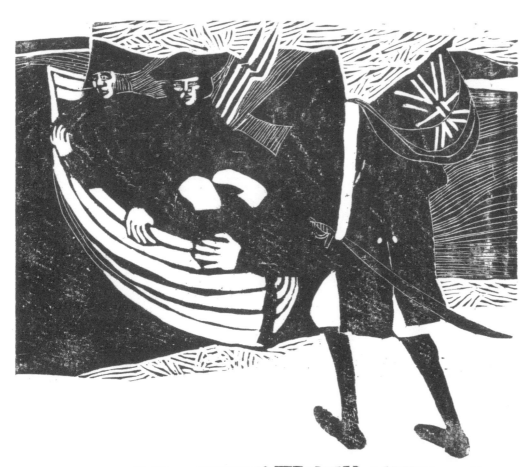

MEANWHILE, HIS FRIEND, TROUGH ALLEY AND STREET,
WANDERS AND WATCHES WITH EAGER EARS,
TILL IN THE SILENCE AROUND HIM HE HEARS
THE MUSTER OF MEN AT THE BARRACK DOOR
THE SOUND OF ARMS, AND THE TRAMP OF FEET
AND THE MEASURED TREAD OF THE GRENADIERS,
MARCHING DOWN TO THEIR BOATS ON THE SHORE

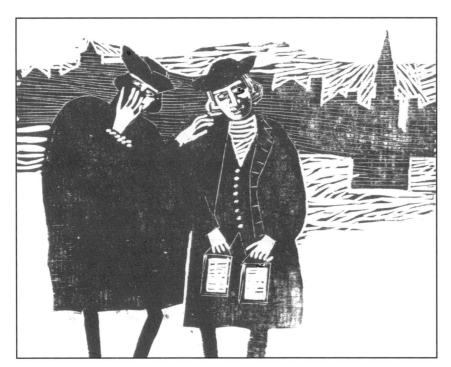

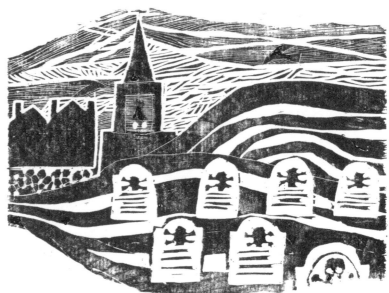

This page and opposite: Book
project for UT class /
Paul Revere's Ride

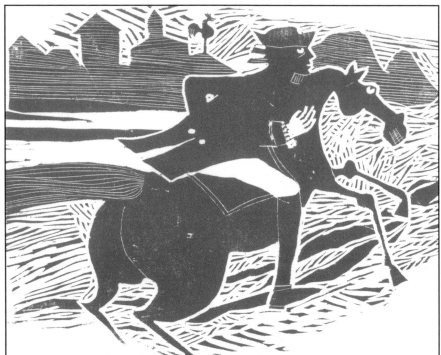

Personal
Work

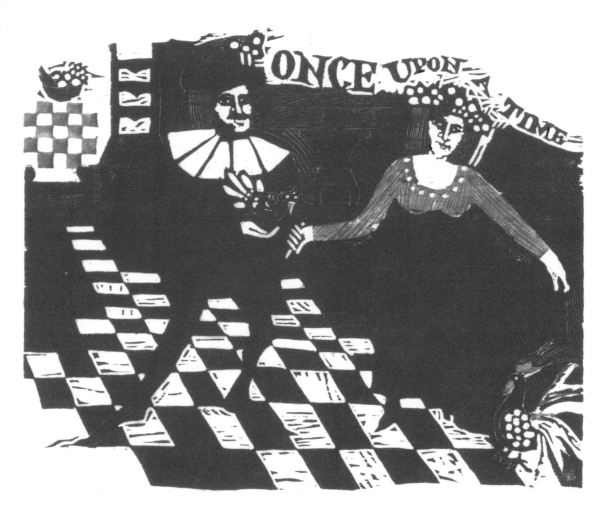

Book project for MFA thesis at UT / *The Three Sillies*

134

THERE WAS A FARMER AND HIS WIFE WHO HAD ONE DAUGHTER, AND SHE WAS COURTED BY A GENTLEMAN. EVERY EVENING HE USED TO COME AND SEE HER, AND STOP TO SUPPER AT THE FARMHOUSE, AND THE DAUGHTER USED TO BE SENT DOWN INTO THE CELLAR TO DRAW THE ALE FOR SUPPER.

Book project for MFA thesis at UT / *The Three Sillies*

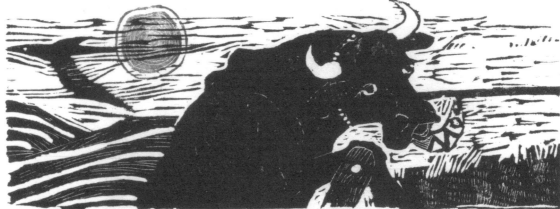

SHE'LL BE QUITE SAFE, FOR I SHALL TIE
A STRING ROUND HER NECK, AND PASS IT
DOWN THE CHIMNEY, AND TIE IT TO MY
WRIST AS I GO ABOUT THE HOUSE, SO
SHE CAN'T FALL OFF WITHOUT MY KNOW-
ING IT." "OH YOU POOR SILLY!" SAID THE
GENTLEMAN, "YOU SHOULD CUT THE GRASS

Book project for MFA thesis at UT / *The Three Sillies*

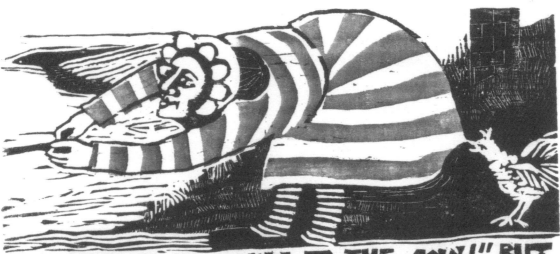

AND THROW IT DOWN TO THE COW!" BUT
THE WOMAN THOUGHT IT WAS EASIER
TO GET THE COW UP THE LADDER THAN
TO GET THE GRASS DOWN, SO SHE
PUSHED HER AND COAXED HER AND GOT
HER UP, AND TIED A STRING ROUND HER
NECK, PASSED IT DOWN THE CHIMNEY,
AND FASTENED IT TO HER OWN WRIST.

Book project for MFA thesis at UT / *The Three Sillies*

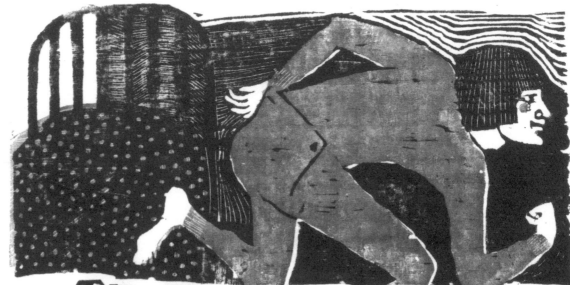

Book project for MFA thesis at UT / *The Three Sillies*

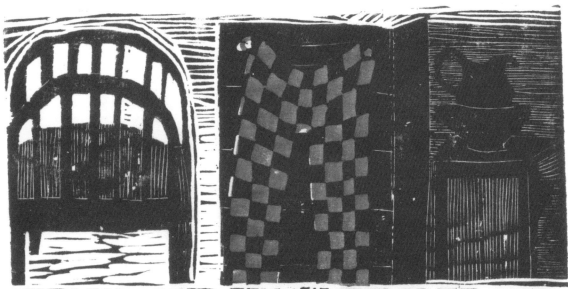

VERY PLEASANT FELLOW; BUT IN THE MORN-
ING WHEN THEY WERE BOTH GETTING UP
THE GENTLEMAN WAS SURPRISED TO SEE
THE OTHER HANG HIS TROUSERS ON THE
KNOBS OF THE CHEST OF DRAWERS AND RUN
ACROSS THE ROOM TO TRY TO JUMP INTO THEM

Book project for MFA thesis at UT / *The Three Sillies*

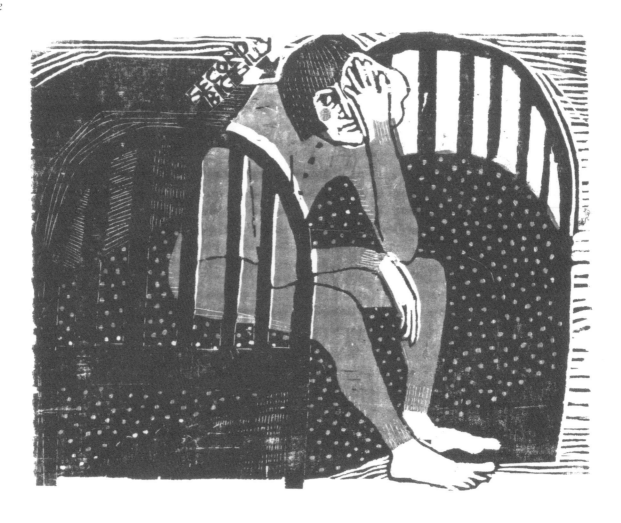

Book project for MFA thesis at UT / *The Three Sillies*

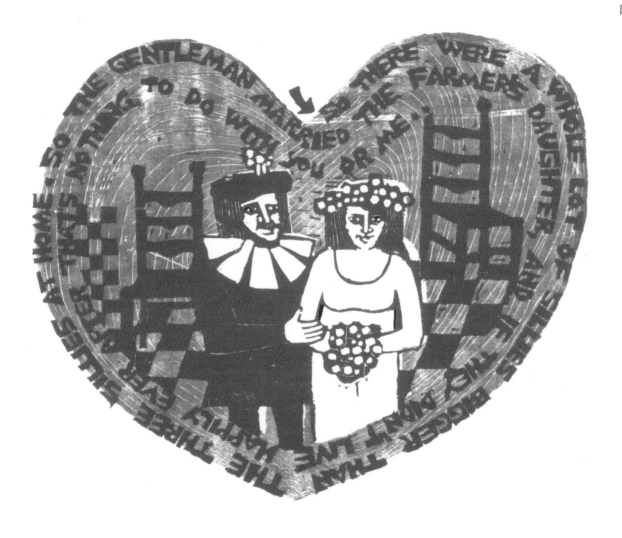

Book project for MFA thesis at UT / *The Three Sillies*

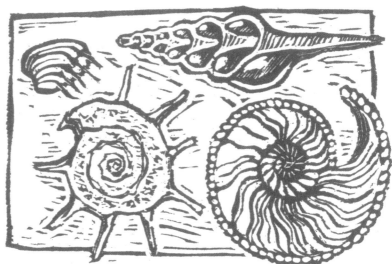

142

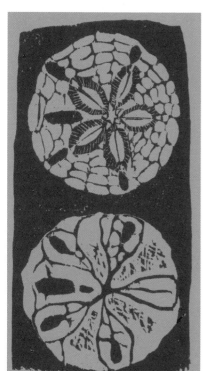

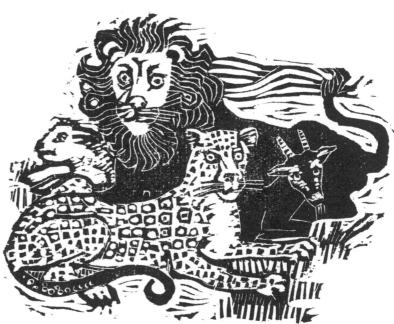

Above: Christmas card for Whitehead family

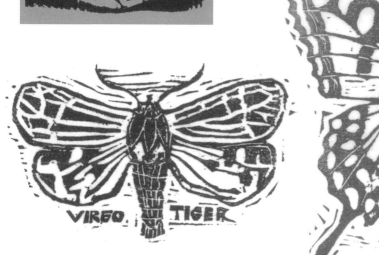

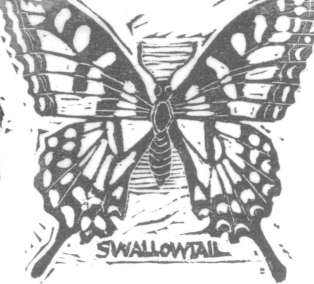

143

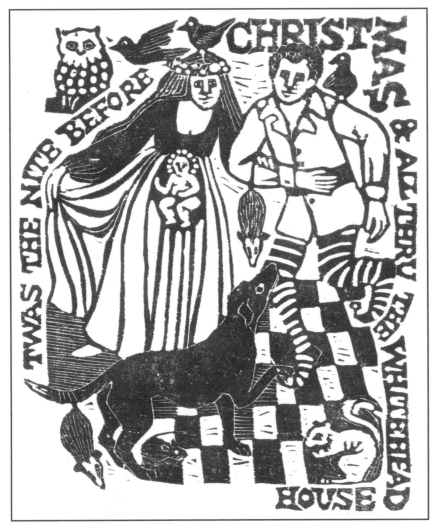

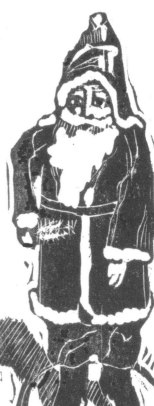

Above: Family Christmas card in 1969 before the birth of Elizabeth

144

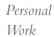

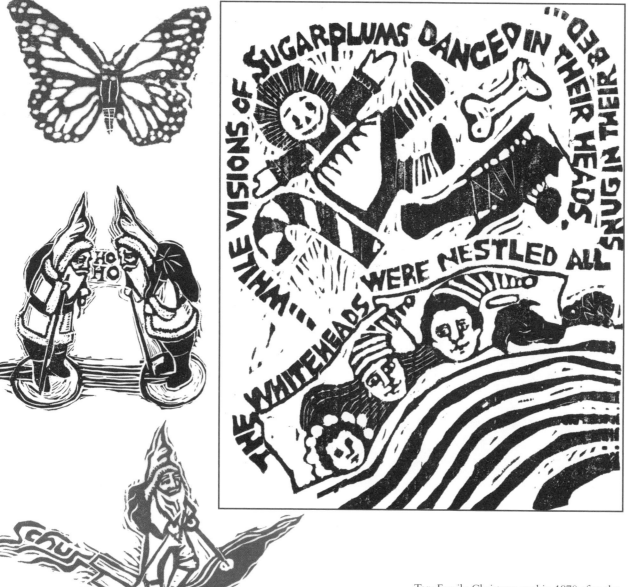

Top: Family Christmas card in 1970 after the
birth of Elizabeth and after the death of the
family dog, Simone.

145

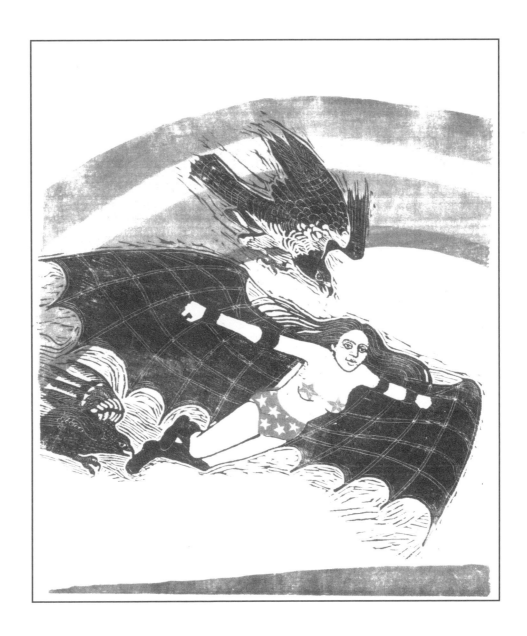

Woodcut displayed at St. Edward's University, Austin, art exhibition, "The Big Air Show"

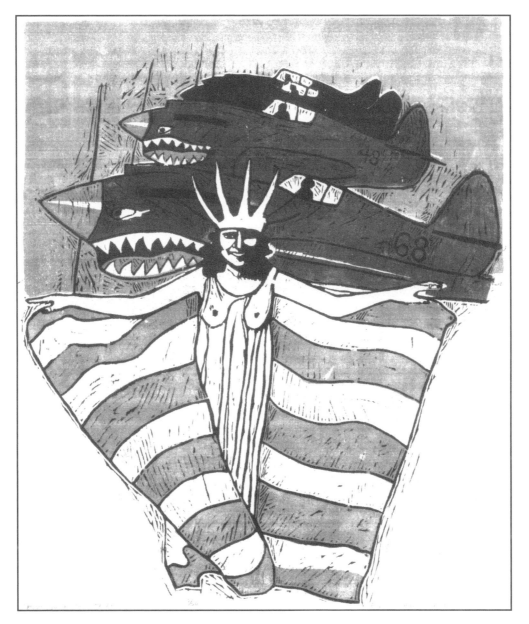

Woodcut displayed at St. Edward's University, Austin, art exhibition, "The Big Air Show"

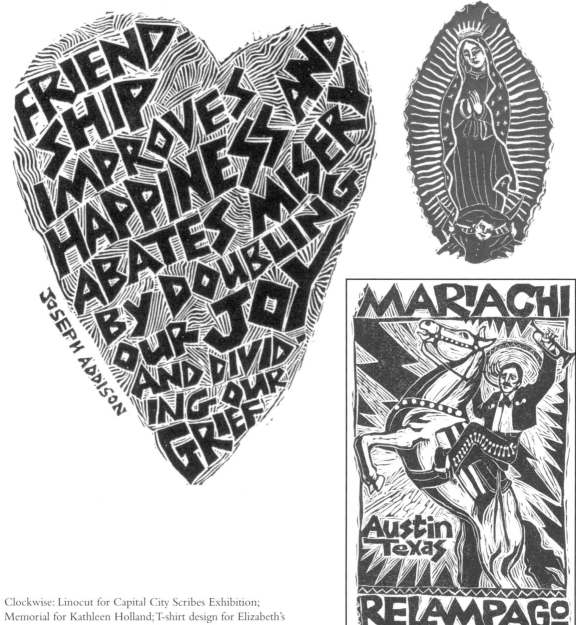

Clockwise: Linocut for Capital City Scribes Exhibition;
Memorial for Kathleen Holland; T-shirt design for Elizabeth's
mariachi group

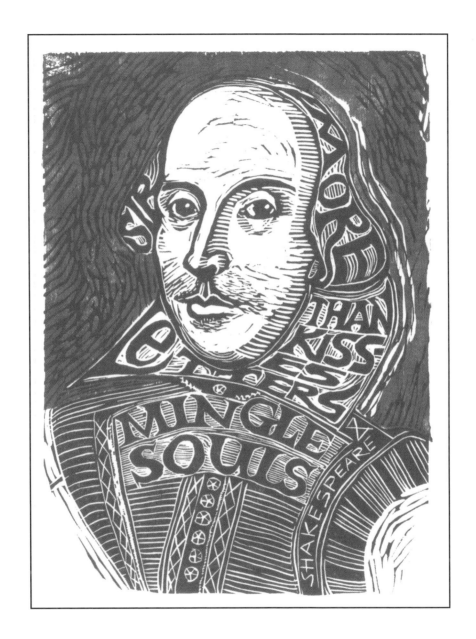

Linocut for Capital City Scribes Exhibition

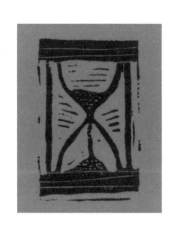

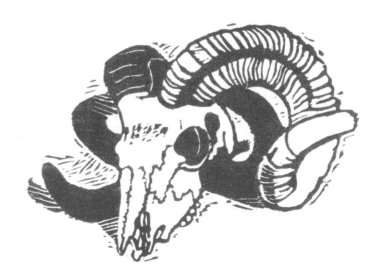

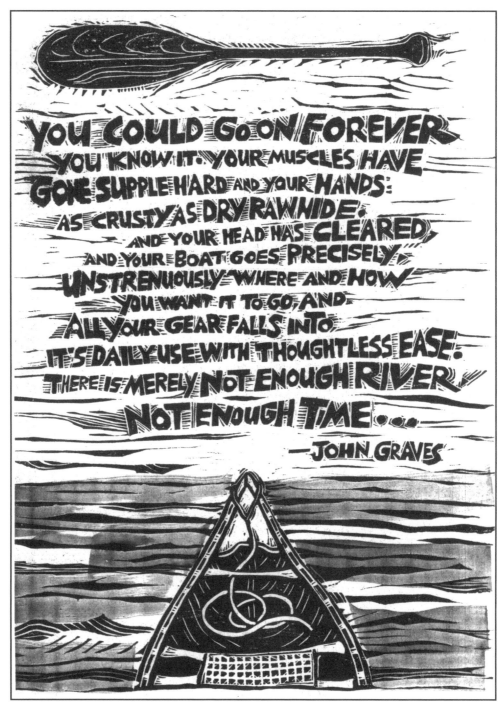

YOU COULD GO ON FOREVER,
YOU KNOW IT. YOUR MUSCLES HAVE
GONE SUPPLE HARD AND YOUR HANDS:
AS CRUSTY AS DRY RAWHIDE.
AND YOUR HEAD HAS CLEARED,
AND YOUR BOAT GOES PRECISELY,
UNSTRENUOUSLY WHERE AND HOW
YOU WANT IT TO GO, AND
ALL YOUR GEAR FALLS INTO
IT'S DAILY USE WITH THOUGHTLESS EASE:
THERE IS MERELY NOT ENOUGH RIVER,
NOT ENOUGH TIME....
—JOHN GRAVES

Quote from *Goodbye to a River* / linocut with watercolor

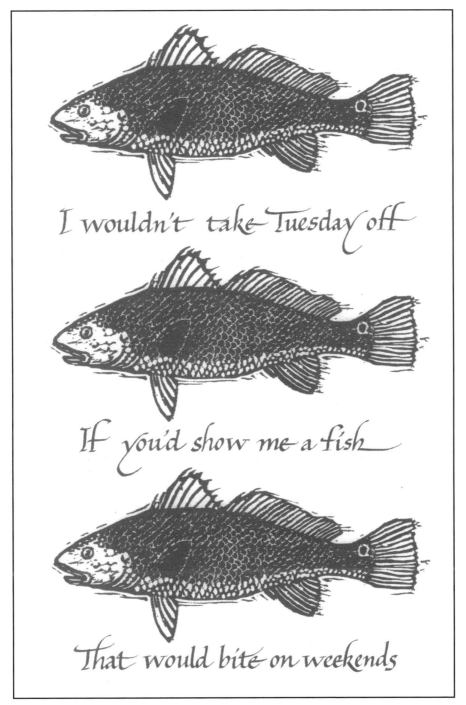

Broadside for Whitehead & Whitehead

153

Acknowledgments

First I am grateful to Hal Normand of Shadetree Studios in Fort Worth for suggesting this book to Judy Alter, director of the TCU Press, and to Judy for all the many years of support of my work. She has generously allowed me to grow in my art by keeping me on a long leash. Thank you, Lonn Taylor, for writing the greatly flattering introduction. I am fortunate that my daughter, Elizabeth Whitehead Chappell, inherited her father Fred's writing talents and took the time from her own work on her Ph.D in Music Education to edit my foreword. She and her family keep my life in perspective. Thanks also to my former officemate, Carolyn Osborn, for her help. Finally, I appreciate all my many clients and friends that have supported my work through the years.

Bibliography

Abernethy, Francis Edward, *Texas Toys and Games,* Dallas, SMU Press, 1989

Albro, Ward S., *Always a Rebel,* Fort Worth, TCU Press, 1992

Almon, Bert, *This Stubborn Self,* Fort Worth, TCU Press, 2002

Anderson, John Q., *Texas Folk Medicine,* Austin, Encino Press, 1970

Arreola, Juan José, *The Fair,* Austin, University of Texas Press, 1977

Austin, Mary, *Earth Horizon,* Albuquerque, University of New Mexico Press, 1991

Baxter, Gordon, *Village Creek,* Bryan, Shearer Publishing, 1981

Brashear, Charles, *Killing Cynthia Ann,* Fort Worth, TCU Press, 1999

Carroll, J. M., *Just Such a Time,* Austin, Kairos Press, 1987

Condon, Phil, *River Street,* Dallas, SMU Press, 1994

Crook, Elizabeth, *The Raven's Bride,* Dallas, SMU Press, 1993

Davis, Steven L., *Texas Literary Outlaws,* Fort Worth, TCU Press, 2004

De León, Arnoldo, *The Tejano Community, 1836-1900,* Dallas, SMU Press, 1997

Donahue, Jack, *Hack Donavon of the* PRESS, Bryan, Shearer Publishing, 1984

Eckstein, Alexander, *China's Economic Development,* Ann Arbor, University of Michigan Press

Elder, Jane Lenz, David J., Weber, editors, *Trading in Santa Fe,* Dallas, SMU Press / DeGolyer Library, 1996

Farris, Frances Bramlette, *From Rattlesnakes to Road Agents,* Fort Worth, TCU Press, 1985

Fields, Helen Mangum, *Walking Backward in the Wind,* Fort Worth, TCU Press, 1995

Fisher, Lewis F., *Saving San Antonio,* Lubbock, Texas Tech University Press, 1996

Flynn, Robert, *North To Yesterday,* Fort Worth, TCU Press, 1985

Gordon, Alice, *Neiman-Marcus Red River's Round Up Cookbook,* Austin, Whitehead Publishing, 1981

Greene, A.C., *Living Texans,* Austin, Hendrick-Long / Encino Press, 1970

Greene, A.C., *Memory of Snow,* Dallas, Browder Springs, 2002

Growing Up in Texas, Austin, Encino Press, 1972

Hale, Leon, *Supper Time,* Houston, Winedale Publishing, 1999

Bibliography

Hannah, James, *Desperate Measures,* Dallas, SMU Press, 1988

Hearon, Shelby, *Hug Dancing*, Fort Worth, TCU Press,2006

Kelton, Elmer, *The Man Who Rode Midnight,* Fort Worth, Texas, TCU Press, 1990

_____, *The Day the Cowboys Quit,* Fort Worth, TCU Press, 1986

_____, *The Man Who Rode Midnight,* Fort Worth, TCU Press, 1990

_____, *The Good Old Boys,* Fort Worth, TCU Press, 1985

_____, *The Time It Never Rained,* Fort Worth, TCU Press, 1984

_____, *Honor at Daybreak,* Fort Worth, TCU Press, 2002

_____, *Wagontongue,* Fort Worth, TCU Press, 1996

_____, *Stand Proud,* Fort Worth, TCU Press, 1991

_____, *Manhunters,* Fort Worth, TCU Press, 1992

_____, *Smiling Country,* Fort Worth, TCU Press, 2006

King, Larry L, *The One-Eyed Man,* Fort Worth, TCU Press, 2001

Lackey, Louana M., *The Pottery of Acatlán,* Norman, University of Oklahoma Press, 1982

Lawrence, D. H., *The Body Of God,* Somerset, England, The Ark Press, 1970

Latorre, Dolores L., *Cooking and Curing with Mexican Herbs,* Austin, Encino Press, 1977

Lindsey, David L. *The Wonderful Chirrionera and Other Tales from Mexican Folklore,* Austin, Heidelberg Publishers, Inc, 1974

Lowman, Al, *This Bitterly Beautiful Land,* Austin, Roger Beacham, 1970

Lucas, Paul R., *Valley of Discord,* Hanover, New Hampshire, University Press of New England, 1979

Martin, Howard N., *Myths & Folktales of the Alabama-Coushatta Indians of Texas,* Austin, Encino Press 1977

Martinez, Oscar J., *Border Boom Town,* Austin, University of Texas Press, 1982

McClintock, Marian and Simms, Michael, editors, *O'Henry's Texas Stories,* Dallas, Still Point Press, 1986

McKinney, Wilson, *¡Carrasco!,* Austin, Heidelberg Publishers, Inc., 1975

Menton, Seymour, *Prose Fiction of the Cuban Revolution,* Austin, University of Texas Press, 1978

Messick, Hank, *Desert Sanctuary,* Albuquerque, University of New Mexico Press, 1987

Morehead, Judith and Richard, *The Texas Wild Game Cookbook,* Austin, Encino Press, 1972

Navas, Deborah, *Things We Lost, Gave Away, Bought High and Sold Low,* Dallas, SMU Press, 1992

Olien, Roger M., and Diana Davids, *Wildcatters: Texas Independent Oilmen,* Austin, Texas Monthly Press, 1984

Osborn, Carolyn, *The Grands,* Austin, The Book Club of Texas, 1990

_____, *Warriors and Maidens,* Fort Worth, TCU Press, 1991

Pierce, Gerald S., *Texas Under Arms,* Austin, Encino Press, 1969

Priddy, B.L. "Bud," *Fly-fishing the Texas Hill Country,* Austin, W. Thomas Taylor, 1994

Remembering Bill: A Tribute to William H. Shearer, Privately published, 1997

Richardson, Rupert Norval, *The Comanche Barrior to South Plains Settlement,* Abilene, Hardin Simmons University, 1991

Rozelle, Ron, *Touching Winter,* Fort Worth, TCU Press, 2005

Trenckmann, William A., *Christmas in Troubled Times,* Round Top, Texas, Friends of Winedale, 1976

Santoni, Pedro, *Mexicans at Arms,* Fort Worth, TCU Press, 1996

Seale, William, *San Augustine in the Texas Republic,* Austin, Edward and Anne Clark, 1969

Shrake, Edwin, *Peter Arbiter,* Austin, Encino Press, 1973

Shuffler, R. Henderson, *Many Texans,* Austin, Hendrick-Long / Encino Press, 1970

Simmen, Edward, editor, *Gringos in Mexico,* Fort Worth, TCU Press, 1988

Sinks, Julia Lee, *Chronicles of Fayette,* privately printed, 1975

Smith, C.W., *Thin Men of Haddam,* Fort Worth, TCU Press, 1990

Texas Monthly Magazine, August 1973

The Economic Regulation of Western Coal Transportation, Austin, Lyndon B. Johnson School of Public Affairs Policy Research Project Report, 38

Tower, Berl Goodwin, *Poesy and Mirth,* Austin, Clearstream Press, 1983

Vliet, R. G., *Clem Maverick,* Fredericksburg, Shearer Publishing, 1983

Vliet, R. G., *Solidad or Solitudes,* Fort Worth, TCU Press, 1986

Vliet, R. G., *Rockspring,* Dallas, SMU Press, 1992

Watt, Don and Lynn, *Fredericksburg, Texas,* Fredericksburg, Shearer Publishing, 1987

Weems, John Edward, *A Texas Christmas: A Miscellany of Art, Poetry and Fiction,* Dallas, Pressworks,1983

Weigle, Marta, editor, *Hispanic Arts and Ethnohistory in the Southwest,* Santa Fe, Ancient City Press, 1983

Whiting, Allen S. *The Chinese Calculus of Deterrence,* Ann Arbor, University of Michigan Press, 1979

Bibliography

Wilson, John, *High John the Conquerer,* Fort Worth, TCU Press, 1998

Wieland, Mitch, *Willy Slater's Lane,* Dallas, SMU Press, 1996

Yount, John, *Toots in Solitude,* Dallas, SMU Press, 1995

Zesch, Scott, *Alamo Heights,* Fort Worth, TCU Press, 1999

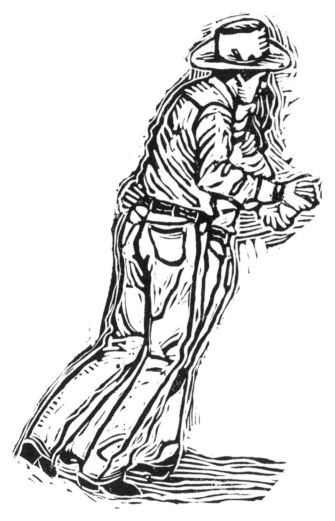

Hug Dancing / TCU Press

Typeset in Bembo—first used by Aldus Manutius who commissioned a new roman type for an essay by Pietro Bembo in Renaissance Venice. In the 1920s Monotype Corp. revived Bembo using antique specimens.

Design and production by
Barbara Mathews Whitehead
2006